CLAUDE & FRANÇOIS-XAVIER

LALANNE

NATURE TRANSFORMED

CLAUDE & FRANÇOIS-XAVIER
LALANNE
NATURE TRANSFORMED

Kathleen M. Morris

Clark Art Institute
Williamstown,
Massachusetts

Distributed by
Yale University Press,
New Haven and London

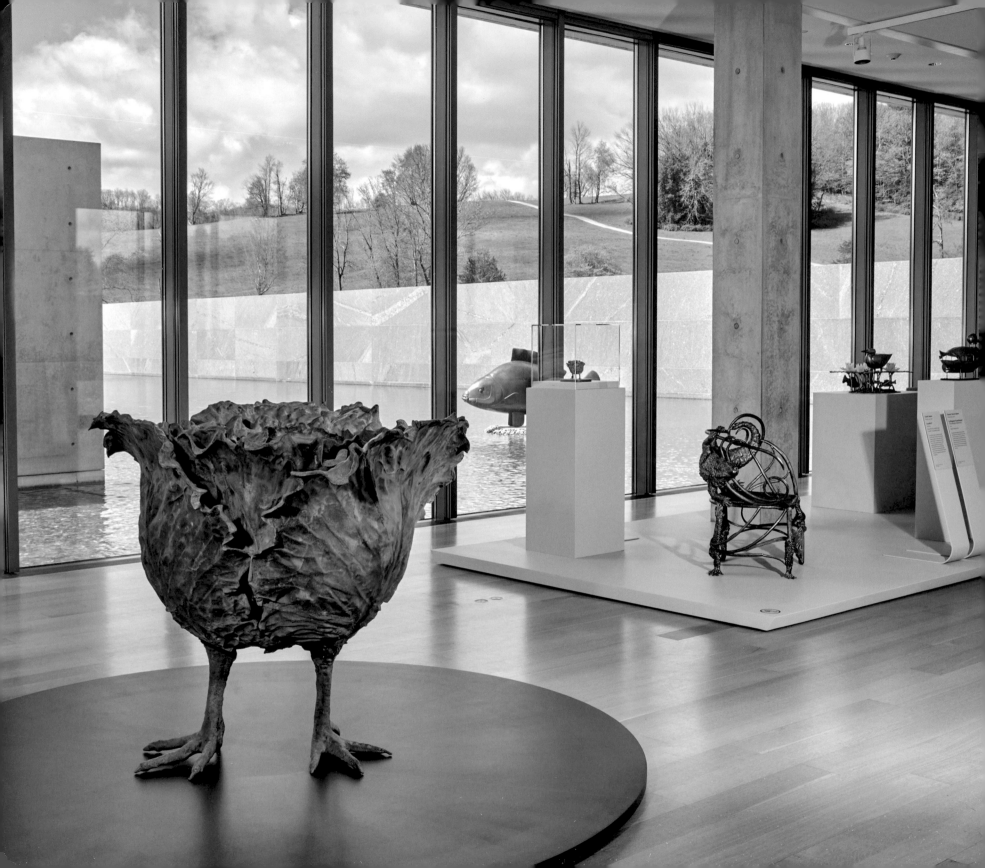

DEDICATION

This exhibition was originally scheduled to take place May 9–November 1, 2020, and was postponed due to the coronavirus pandemic. We dedicate this publication to the lenders for trusting us to go forward with the exhibition in 2021.

CONTENTS

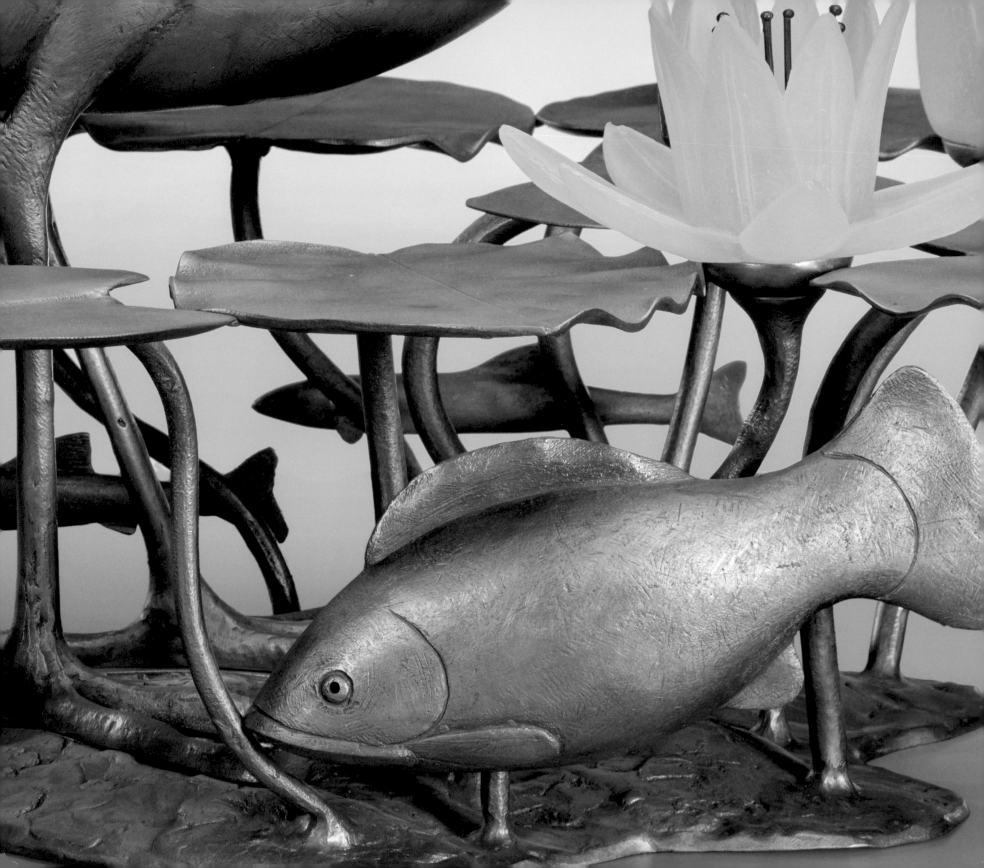

FOREWORD

OLIVIER MESLAY
HARDYMON DIRECTOR

TIME AND AGAIN I HAVE DREAMED OF
ORGANIZING AN EXHIBITION OF WORK BY CLAUDE
LALANNE AND FRANÇOIS-XAVIER LALANNE,
THE DELIGHTFULLY COMPLEX ARTIST DUO WHO
EXHIBITED THEIR WORKS JOINTLY UNDER A
SINGLE NAME, "LES LALANNE." With *Claude &
François-Xavier Lalanne: Nature Transformed*, curated by
Kathleen M. Morris, my hopes to capture the beauty of
their artworks, champion the fascination they inspire in
others, explore their dualities and commonalities, and,
above all, offer a brief and recurring moment of happiness
for viewers have been realized. Conveying the essence of art
by Les Lalanne is a challenging endeavor. A crucial aspect
of understanding their work is appreciating their self-
directed symbiosis: they were a couple who only exhibited
together, under one name, but almost never collaborated in
the genesis of their individual works, a situation that defies
expectations and common understandings of romantic
(and artistic) partnerships. Collectively, their artworks
evoke multisensory memories and spark immediate
enjoyment—Proustian pleasures that do not arise from the
past, but rather are formed in the present. Perhaps the most
mysterious effect of the artists' creations—"Lalannes," as

they are known—is the fascination they inspire in those who encounter them or are fortunate enough to possess them.

Rare is the art that offers, simultaneously, impressions of duration, preciousness, refinement, thoughtfulness, and a lack of intimidation. To understand the strength of Les Lalanne's works, one has to accept an art in which access to the works, intellectual as well as physical, is immediate, warm, and easy. This condition is due in part to the functional aspect of some of their objects. Everyone works at a desk, puts away bottles and glasses, and looks in a mirror. When combined with their surprising signature details of flora and fauna, Les Lalanne bring these everyday objects alive with humor and wonder. While humor does not always succeed in the art world, here it plays with a certain grandeur and seriousness, built on knowledge without being

corrosive. The joyfulness of Les Lalanne's artworks, as well as the aspects of Surrealism that permeated their art when they began exhibiting at the Galerie Alexandre Iolas in Paris in the mid-1960s, adds to the artists' enigmatic aesthetic. All this makes Les Lalanne unique.

The architecture of Tadao Ando, the reflecting pools, and the magical luminosity of the Berkshire sky in the Conforti Pavilion create the ideal atmosphere for spending time with Lalannes. With Jarrod Beck's elegant exhibition design and Morris's incredible curatorial leadership, this exhibition marks a major visual and scholarly landmark among celebrations and studies of Les Lalanne. This catalogue, with its essay by Morris, offers new perspectives on their art for lifelong enthusiasts and fresh admirers alike. The moment for this undertaking is overdue: apart from a 2010 retrospective at the Musée des Arts Décoratifs in Paris, American and European museums have been particularly quiet on the subject of Les Lalanne. This exhibition introduces the artists to a new generation and presents an opportunity to change the way the museum world has seen them in the past.

In addition to Morris's invaluable leadership in organizing this exhibition, it would not have been possible without the assistance and support of the Lalanne family (especially Claude, who gave the project her blessing prior to her death in April 2019) and the Lalanne studio; the late Paul Kasmin, Edith Dicconson, Nick Olney, and Chandler Alan at Kasmin Gallery, New York; Jean-Gabriel Mitterrand at Galerie Mitterrand, Paris; and Ben Brown at Ben Brown Fine Arts, London. Thanks to Laura and Stafford Broumand, Ben Brown Fine Arts, Galerie Lefebvre, Norton Museum of Art, and Brian McCarthy and Daniel Sager for their generous loans to the exhibition. We are also grateful to the additional private collectors who have lent works. Those outside the Clark who assisted with research and advice include Florent Jenniard

and Jodi Pollack of Sotheby's, Bart H. Ryckbosch of the Art Institute of Chicago, Adrian Dannatt, André Mourgues, Marie-Isabelle Pinet-Netter, and Sandrine Guillard, while within the Clark we thank Nidhi Gandhi and the Clark librarians. Assembling and mounting the exhibition would not be possible without the dedicated work of Paul Dion, Mattie Kelley, Samantha Page, and many others. We also extend our gratitude to Denise Littlefield Sobel, Sylvia and Leonard Marx, the Kenneth C. Griffin Charitable Fund, Jeannene Booher, Agnes Gund, and Robert D. Kraus for their support of the exhibition, and to Denise Littlefield Sobel, the Kenneth C. Griffin Charitable Fund, and Furthermore: a program of the J. M. Kaplan Fund, for their generous grants supporting this publication.

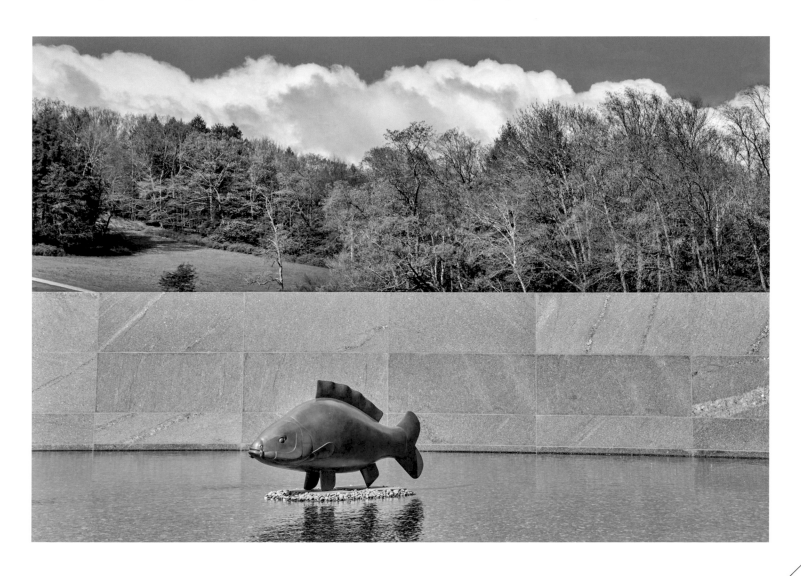

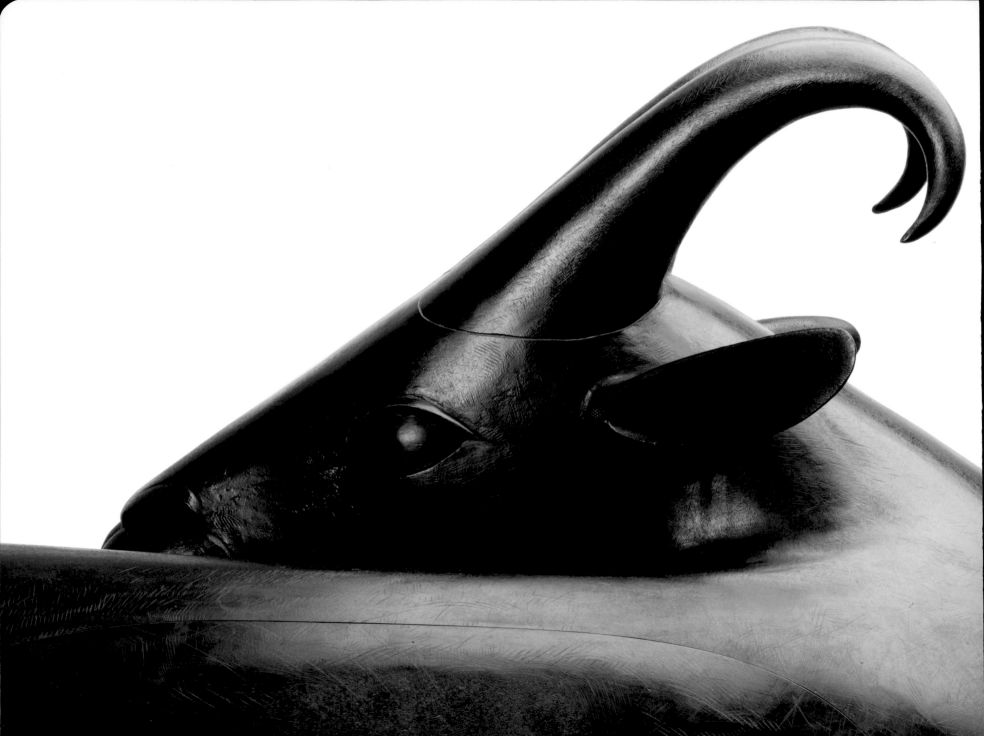

"Claude and François Lalanne are to the art of furniture and objects what Gaudí was to architecture, Satie to music, and a Dada-dabbling Magritte to painting."

DANIEL MARCHESSEAU, 1974[1]

POLYMORPHOUS DREAMS: THE ART AND CAREERS OF FRANÇOIS-XAVIER AND CLAUDE LALANNE

KATHLEEN M. MORRIS

BEGINNING WITH THEIR FIRST SELF-DESCRIBED "JOINT SOLO SHOW" IN 1964, CLAUDE LALANNE (1924–2019) AND FRANÇOIS-XAVIER LALANNE (1927–2008) HAVE ASTONISHED AND DELIGHTED AUDIENCES WHEREVER THEIR ART IS DISPLAYED. Critics and biographers have sought words to capture the unique nature and impact of their work, such as "polymorphous dreams,"[2] "sculpture puns,"[3] "madly witty sculpture-objects,"[4] "fairytale surrealism,"[5] and "white magic."[6] They have made works for clients, public and private, around the world, and are included in the most important private collections of contemporary art. And yet, their art has been overlooked by the museum world, where it is not so much criticized as ignored. This is perhaps especially true in the United States—home to many of their most important private collectors—where their art is virtually absent from museum collections.[7]

Claude & François-Xavier Lalanne: Nature Transformed at the Clark Art Institute represents the first art museum exhibition dedicated to the couple in the United States since 1977,[8] and the first art museum exhibition to take place following the retrospective of their work at the Musée des Arts Décoratifs in Paris in 2010. The good-humored and tongue-in-cheek nature of much of their production has led many to overlook its sophistication and complex associations. *Nature Transformed* takes the artists seriously and disregards snobbish attitudes that would relegate their works to a category of kitsch or playthings for the rich. We began planning this exhibition several years ago, prior to Claude's death in April 2019 and the spectacular estate sale at Sotheby's later that year. At a moment when it is natural to pause and assess their long careers, it seems fitting to reappraise these extraordinary artists within the context of the fine art museum.

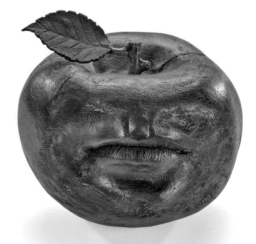

> *"Monsieur wields the tool of surprise,*
> *Madame enters the world of dreams."*
>
> RAINER MICHAEL MASON, 1971[9]

LES LALANNE: WORK AND LIFE

Over the years, torrents of words have been written about the Lalannes—usually accompanied by a wealth of images of them and their storied lifestyle, their fairytale-like house and studio in Ury, south of Paris, and their inventive creations that call for photography from multiple points of view. It is hard to boil down their extraordinary story into few words. This exhibition and catalogue intend to reintroduce these artists to an American museum audience, provide an overview of their careers and critical reception, and examine one of the most central themes of their art: the transformation of natural forms.[10]

François-Xavier was born in Agen in southwestern France in 1927 and received a robust education at a Jesuit school that invested him with an abiding interest in history, philosophy, and classical languages. Starting in 1945 he trained as a painter and sculptor at the Académie Julian in Paris. For about six months in 1949–50 François-Xavier held a job as a security guard at the Musée du Louvre, where he was assigned to the galleries of ancient Egyptian and Assyrian art. He was particularly impressed by certain totemic animal sculptures such as the *The Apis Bull* (fig. 1), which he claimed to have climbed on in quiet moments.[11] In 1949 François-Xavier moved into a small studio in the warren-like Impasse Ronsin

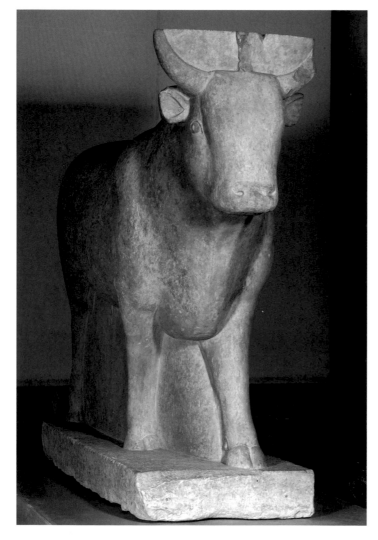

in Montparnasse, a hotbed of artistic activity. There he lived and worked among other artists, including Constantin Brancusi, Max Ernst, Yves Klein, James Metcalf, Martial Raysse, Niki de Saint Phalle, and Jean Tinguely, all of whom were to become friends.

Claude Dupeux was born in 1924 in Paris. She studied architecture at the École des Beaux-Arts and the École Nationale des Arts Décoratifs. Her mother was a pianist and, given her later concentration on working with metal, it is interesting to note that her father had worked as a gold trader and dabbled in alchemy. Both François-Xavier and Claude had children from first marriages—he had one daughter, Dorothée, and she had three, Valérie, Caroline, and Marie. They met in 1953 at a reception for François-Xavier's first solo show of paintings. Within a few years they began working together during a period of what one biographer called "privileged servitude,"[12] doing set design for theater and film as well as window and shop design for firms such as Christian Dior, Lanvin, and Le Printemps.[13] They began focusing more and more on metalworking techniques, and along with friend Metcalf, who was also a sculptor, Claude taught herself the old-fashioned method of galvanoplasty, or electrotyping.[14] Claude experimented with the galvanic baths

until she was an expert, developing a process that became one of her hallmarks.[15] Around 1960, as the increasingly decrepit Impasse Ronsin was slowly being closed, François-Xavier and Claude moved to nearby Impasse Robiquet and married on February 6, 1962. They realized they needed to concentrate on creating their own sculpture rather than commissioned design work and were delighted when Jeanine de Goldschmidt of Galerie J in Paris decided to give them their first show.

The Galerie J exhibition ran from June 25 to October 15, 1964,[16] launching their careers as independent artists in a definitive way. It was accompanied by a twelve-page catalogue featuring an essay by Metcalf and images of some of the works shown. François-Xavier had worked for the better part a year on his single display: a metal rhinoceros whose armor-like sections lift to reveal the components of a bar. Weighing over six hundred pounds, the life-size *Grand Rhinocéros I* (Large rhinoceros I, 1964) made an immediate impact. The other thirteen works featured in the show's catalogue were by Claude, demonstrating her mastery of galvanic and other metalworking techniques: her first *Marcassin* (1964, fig. 2), a young wild boar engulfed in strawberry vines; the first two of her *Choupattes* (1964),

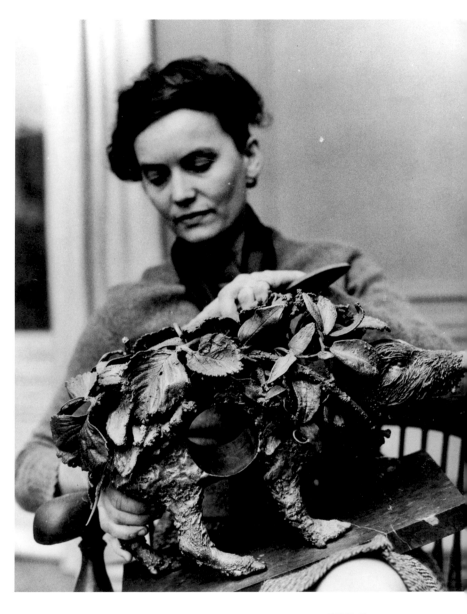

FIG. 2
Claude Lalanne finishing the first *Marcassin*, 1964.

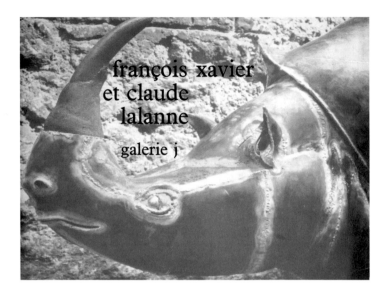

Galerie "J"
8, rue de Montfaucon - PARIS - 6ᵉ - DAN 30 - 65
(angle boulevard Saint-Germain - rue du Four)

François et Claude Lalanne *ZOOPHITES*

Vernissage le Jeudi 25 Juin 1964 à partir de 18 heures

FIG. 3
Front cover of catalogue and announcement
card for *Zoophites* at Galerie J, Paris, 1964.

cabbages that stand on chicken feet; watches hidden
inside compartmentalized onions; and belts formed from
galvanized bits of nature.

Sometime between printing the catalogue for the 1964
exhibition at Galerie J and its opening, the title *Zoophites*
was applied to the show. The word does not appear in
the catalogue, with its celebratory essay by Metcalf, but
shows up on the gallery's announcement card for the show
(fig. 3). It was no doubt coined by François-Xavier, whose
love of wordplay was central to his practice. "Zoophite"
(or "zoophyte") is a term used in premodern scientific
classification to categorize objects that have characteristics
of both animals and plants. The concept of strange and even
impossible combinations of the plant and animal world
perfectly captures the ambiguity of the objects included in
the 1964 exhibition. This sense of transformation, turning
familiar, natural forms into phantasmagorical objects, would
remain central to the practices of both François-Xavier and
Claude throughout their careers.

Although it is easy to distinguish which artist made
which works, since their styles are so individual, the list of
works in the 1964 catalogue makes no such distinction. In
1966 the artists decided to exhibit all of their works under

one name, "Les Lalanne,"[17] and they came to refer to their creations as "Lalannes." Although they exhibited together on a regular basis, Claude and François-Xavier seldom worked collaboratively. The objects included in the Galerie J exhibition are indicative of the characteristic style and subject matter developed by each artist. François-Xavier favored large-scale sculptures, which were carefully fabricated based on meticulous plans and drawings. For his subject matter, he turned to the animal world, sometimes infusing animal forms with a new function, as with the rhinoceros-bar, and sometimes, especially later in his career, treating them as pure sculpture. For her part, Claude drew inspiration from the kinds of natural objects she could pluck from her gardens or purchase at local food markets. Her sculptures, watches, and belts in the 1964 exhibition feature natural forms—a small animal, vines, leaves, onions, twigs, cabbages, chicken feet—that had been transmogrified in her electric current baths and assembled by welding components together and finishing the surfaces by hand. She would soon gain fame as well for her works based on galvanized and cast molds of parts of the human body.

The Galerie J show attracted important press coverage. Celebrated American poet and critic John Ashbery wrote a short but positive review for the Paris edition of the *New York Herald Tribune*,[18] for which he served as arts editor. French art historian, writer, and anarchist Michel Ragon, an influential critic of the time who was deeply invested in the avant-garde, included *Grand Rhinocéros I* in an April 1965 article exploring the impact of contemporary art on architecture and interior design, accompanied by images of the work both open and closed.[19] François-Xavier exhibited *Grand Rhinocéros I* again at the 1965 annual group show Salon de la Jeune Peinture along with a large canopied bed in the shape of a bird he titled *Cocodoll*; American-born poet and critic Édouard Roditi singled these out as the most successful works in the show, calling them "masterpieces of fantasy and sheer craftsmanship."[20]

Shortly after the 1964 show at Galerie J, Les Lalanne were taken up by the flamboyant and influential gallerist Alexandre Iolas, who represented many of the late Surrealists. The Lalannes were friendly with these artists, as well as with Salvador Dalí himself, and their work reveals a shared interest in blurring the boundaries between dreams and reality. The rhinoceros can be seen as a Surrealist animal due to its links to both Dalí and to Eugène Ionesco, whose play *Rhinocéros* was first performed in 1959, as well as to François-Xavier, whose transformation of the animal into a bifurcated object—it is one thing when it is closed,

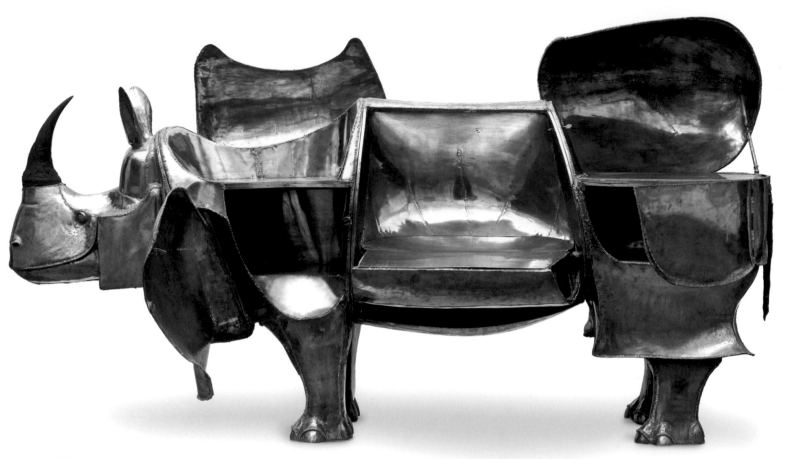

FIG. 4

François-Xavier Lalanne, *Rhinocrétaire II*, 1966. Polished brass sheet over wood, rhinoceros horn, leather, steel, 53¹⁵⁄₁₆ × 118¹⁄₈ × 29¹⁄₈ in. (137 × 300 × 74 cm). Musée des Arts Décoratifs, Paris. Purchased through the Sponsorship of Gregory and Regina Annenberg Weingarten / The Annenberg Foundation through the Friends of the Musée des Arts Décoratifs, 2010, 2010.1.1. © MAD, Paris/Jean Tholance.

and another when it is open—embodies a kind of Surrealist fantasy. The imaginative and humorous associations of Claude's creations, such as watches embedded in onions (playing on the French term *montre oignon*, a thick pocket watch, often with multiple lids) and morphed objects made through organic association like the *Choupattes*, are not so far from Surrealist sculptures, such as Dalí's *Lobster Telephone* (1936). The Lalannes, however, did not associate themselves with any particular art movement, as they made clear in their comments to the press: they were making "Lalannes," something new. François-Xavier amused himself and

perhaps dodged any perceived need to tie the production of his second rhinoceros sculpture in 1966 to any "ism" with explanations such as, "with him, we rhinoceros."[21]

Iolas presented the artists' second show at Galerie Alexandre Iolas in fall 1966, which sparked a mini-storm of press attention. The show, accompanied by a catalogue written by noted journalist, novelist, and editor François Nourissier, included the second version of François-Xavier's rhinoceros—this one a desk, called *Rhinocrétaire II* (Rhinoceros-desk II, 1966, fig. 4)—along with, among other things, a giant fly that opened to become a toilet, a group

of woolen sheep (*Moutons de laine*, 1965–66) that could be used as chairs and ottomans, and a tortoise that moved by remote control and carried drinks under its shell.[22] Claude showed a large suite of flatware formed from a kaleidoscopic combination of galvanized lobster claws, duck feathers, cricket and butterfly wings, flower petals, and other fragments of nature, along with a cigar box in the form of a bunch of bananas and other sculpture and jewelry. Enthusiastic previews of the show appeared in *Connaissance des Arts* and the *New York Times* in October 1966.[23] French businessman and arts patron Pierre Bergé, who cofounded the fashion house of Yves Saint Laurent and was to become one of the Lalannes' important clients and friends, wrote a reverie to the couple and their art in the leftist journal *Combat*, in which he asserted that they were as much poets as artists.[24] The *Moutons de laine* had been shown earlier that year at the Salon de la Jeune Peinture to acclaim (fig. 5).[25] While ostensibly designed to be useable as chairs and ottomans, a herd of twenty-four life-size sheep represents more of an obstacle than practical furniture. Proving that their usability as functional objects was not primary to their original meaning, at first François-Xavier insisted they remain together as a group, as the effect of encountering a dense flock of sheep in unexpected places would be lost with fewer elements. One reporter noted that Yves-Saint Laurent had asked to buy only six, "but the sculptor considered them inseparable. 'It's a bit,' he said, 'as if Rodin had been asked to sell the *Burghers of Calais* by the piece.'"[26]

Life produced a feature on the artists for the February 1967 issue in advance of the Paris show's transfer to Iolas's New York gallery, planned for the spring. *Life* correspondent Bill Wise reported that at the Galerie Alexandre Iolas show in Paris "urbane Parisians queued up" to see the works on display "with all the excitement of children visiting a zoo."[27] Before this article appeared in print, at the turn of 1966–67,

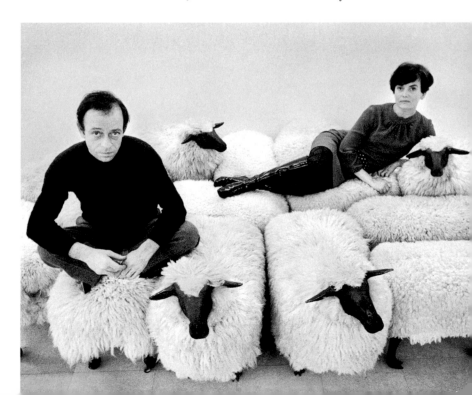

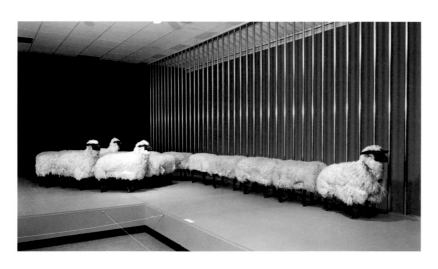

FIG. 6
Installation view of François-Xavier Lalanne, *Moutons de laine*, 1966, in *Sculpture by Claude and François-Xavier Lalanne* at the Art Institute of Chicago, 1967.

curator of twentieth-century art at the Art Institute of Chicago A. James Speyer had a discussion with Iolas's Paris gallery director Bénédicte Pesle at an event in Minneapolis.[28] On January 5, Pesle was back in Paris and wrote Speyer to let him know that his proposal to feature the Lalanne exhibition at the Art Institute before it went on to the Alexander Iolas Gallery in New York had been met with approval. A flurry of letters and telegrams ensued, as time was of the essence. While Speyer hoped to open the Chicago show in early February, the fact that the Lalannes were working to finish several pieces—along with delays in shipping arrangements— meant the exhibition did not open at the Art Institute until March 7, where an imaginative display featured zoo-like ranges of bars, a tether for the tortoise (to keep the immobile sculpture from "escaping"), and a conga line of sheep (fig. 6).[29] Perhaps spurred by the *Life* article, which had just recently hit newsstands,[30] the show was very successful, as Speyer reported back to the gallery.

Also in 1967, Claude and François-Xavier left their cramped quarters in Paris and bought an old farmhouse and adjoining yards in Ury, near the Fontainebleau forest south of Paris, where they were to live and work for the rest of their lives, adding adjacent properties to their compound

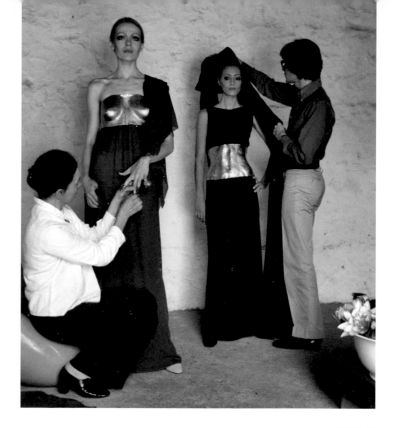

over time. They worked steadily and garnered influential
friends and patrons. They had known fashion designer
Yves Saint Laurent since his days as designer for the House
of Dior, and he became one of their close friends. In 1969
he invited Claude to collaborate on his fall/winter haute
couture collection—she created body molds of the bust and
waist of two of his lead models (fig. 7), and further adorned
them with outré jewelry, such as a bronze ear that fit over the
model's ear, from which hung a galvanized sprig of wisteria,
and bronze fingertips that sprouted small flowers and shells.

While their work began entering private collections—such
as those of Saint Laurent himself, socialite Marie-Hélène
de Rothschild, interior designer Jacques Grange, collector
and philanthropist Anne Gruner Schlumberger (sister of
Dominique de Menil), and art collector, producer, actress, and
model Jane Holzer—the Lalannes also began what would become
a consistent practice of creating art for public spaces. Architect
Émile Aillaud, who was the first owner of the 1966 *Rhinocrétaire
II*,[31] commissioned François-Xavier to create large-scale
sculptures for the affordable housing project in Paris he
designed known as La Grande Borne, resulting in two fifteen-
foot-tall pigeons created in 1970 and a giant head made in 1973.
Over the years both artists' works have appeared in many public

FIG. 8
Installation view of Claude and François-Xavier Lalanne,
The Dinosaurs of Santa Monica, 1989. Copper, steel,
and topiary. Third Street Promenade, Santa Monica,
California.

installations; to name only a few: a giant peace dove mounted
on an obelisk in Jerusalem (1978); sculptures, walkways, and
playgrounds for the Forum des Halles in Paris (1979–86);
topiaries and fountains for the Place de l'Hôtel de Ville in Paris
(1982); a fountain in homage to Brancusi at Necker Hospital,
where Impasse Ronsin had once been (1984); a large-scale
fountain sculpture in Hakone, Japan (1987); six large dinosaur-
shaped topiary fountains for the Third Street Promenade
in Santa Monica, the result of an international competition
(1989, fig. 8)[32]; and a number of sculptures for the grounds of
the Tomson Riviera apartment compound in Shanghai (2007).
Sadly, a planned 1985 renovation at the Central Park Zoo in New
York that would have included elephant topiaries and animal
sculptures by François-Xavier and fences with monkeys and
vines by Claude never came to fruition.[33]

In 1971 noted critic and art scholar Jacques Lassaigne
selected Les Lalanne to represent France in the 11th Bienal de
São Paulo. The display included a number of sculptures and
gouaches by François-Xavier, including a hippopotamus that
opened to reveal a bathtub and a set of *Moutons de laine*. For
Lassaigne, the fact that François-Xavier's sculpture could be
used as a desk, bathtub, or chair was "so natural, so poetic, so
logical that one wonders how one did not think of it earlier."[34]

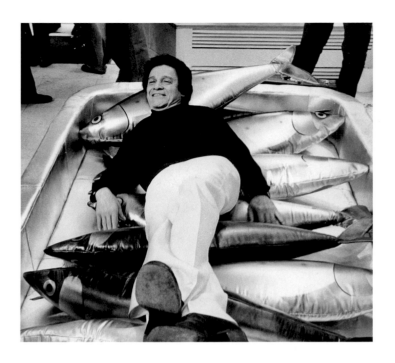

In addition to Claude's work with Saint Laurent, which
brought her unique jewelry to the attention of the general
public, the art of Les Lalanne has impacted popular culture in
other ways. In 1976 the singer-songwriter Serge Gainsbourg
was inspired by Claude's sculpture *L'homme à tête de chou*
(The man with a cabbage head, 1970) to the extent that he
wrote a song and named an album after the sculpture, a
photograph of which appears on the album's cover. Several
of François-Xavier's furniture works were commissioned in
1971 by Holzer's New York firm Daedalus Concepts, including
his *Boîte de Sardines* (Sardine bed, 1971), which was shown at
Leo Castelli Gallery in 1972 (fig. 9). Claude created the breast
plate that celebrated actor Bruno Ganz wore in the 1987 Wim
Wenders film *Der Himmel über Berlin* (released in English as
Wings of Desire), for which she appears in the credits as one of
two project sculptors (fig. 10). François-Xavier's *Moutons de
laine*, which he made in wool and cement versions for display
indoors and out, have captured the collective imagination to
the extent that knockoffs can now be found in innumerable
fashionable furniture storefronts and online interior design
shops. Today, original works by the Lalannes are eagerly
sought by collectors worldwide.

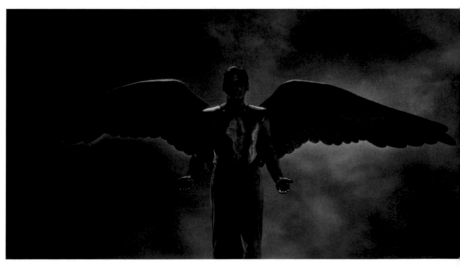

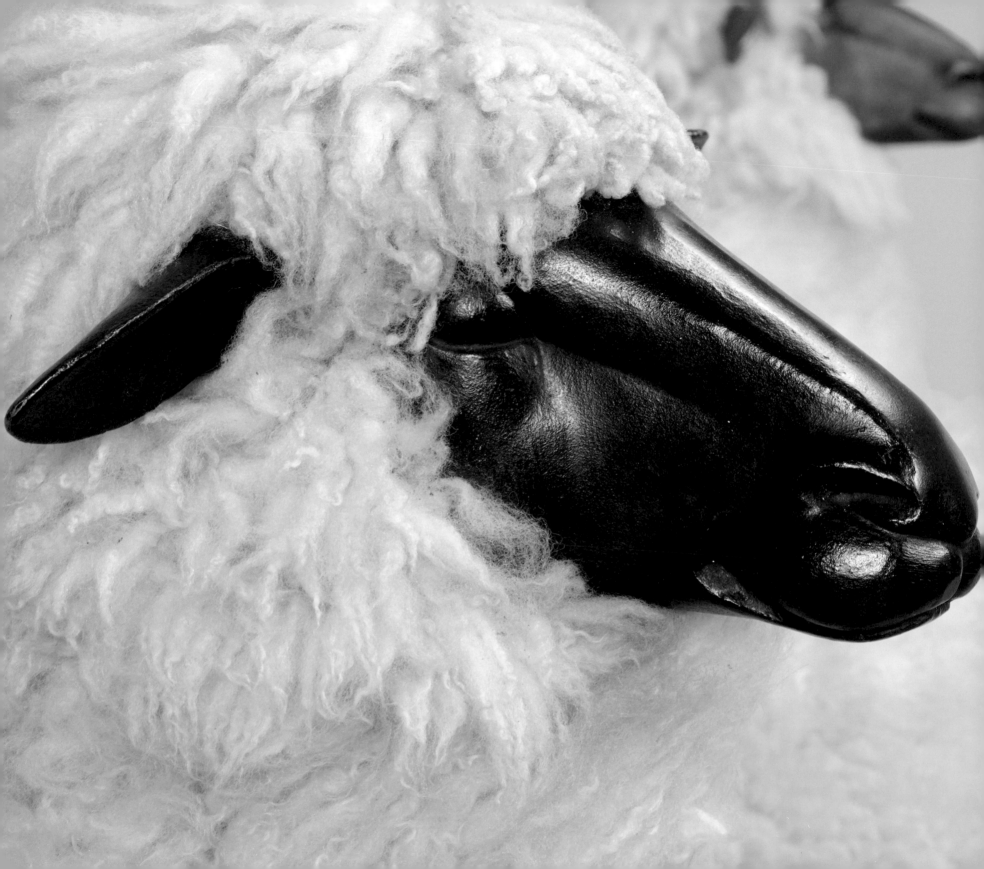

"How do things come to be made? I couldn't explain that. They come as they come, as time passes, from my hands, from a look, or from the work itself."

CLAUDE LALANNE, 1990[35]

"The animal world constitutes the richest and most varied source of forms on the planet. Furthermore, it provides a gigantic vocabulary of signs and metaphors. And do not forget that animals are man's oldest companions."

FRANÇOIS-XAVIER LALANNE, 2007[36]

LES LALANNE AT WORK

While Claude and François-Xavier's artistic practices were deeply entangled, as they shared a home, studio, and exhibitions, their methods of creation remained recognizably distinct over the course of their careers. Drawing remained vital to François-Xavier's artistic practice throughout his life. He described starting each of his animal sculptures by creating a drawing of the animal in silhouette in order to capture the essence of the animal's form.[37] He worked up exacting plans for each sculpture on paper, after which the work was fabricated with little to no variation from the plan. These drawings were essential to François-Xavier's work and were sometimes reproduced in publications that otherwise were about the realized sculptures. For example, the 1966 Galerie Alexandre Iolas exhibition catalogue illustrates a number of drawings, including a detailed one for the mechanized tortoise included in that show (fig. 11), but no photographs of the finished works. In addition to creating comprehensive drawings for his sculpture before fabrication began, François-Xavier also exhibited and published independent drawings and lithographs on a number of occasions, such as a portfolio of color lithographs shown at Galerie La Hune in Paris in 1978 and published as an album with accompanying poems written by him.[38]

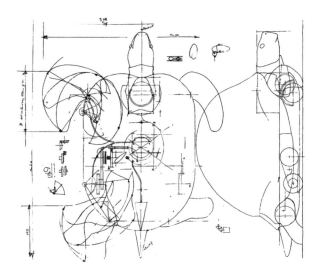

FIG. 11
François-Xavier Lalanne, drawing for
Tortue-bar, in the exhibition catalogue for *Les
Lalannes* at Galerie Alexandre Iolas, Paris,
1966.

François-Xavier's sculptures required precise planning
as the works are exacting in detail and complex in form (fig.
12). Sometimes his creations include cast components that
fit together with little tolerance for error—such as the fired
Sèvres porcelain of his celebrated bar *Les Autruches* (The
ostriches, 1966–67), in which the sculptural birds conceal
hinged compartments. In 1970 Patrick d'Elme reported
how François-Xavier brought his works to fruition with the
assistance of one aide: "He does not start working by chance,
but designs his pieces before beginning their creation . . . his
work is long and meticulous. Almost beyond reproduction,
too, for great attention is given to detail, to patina, to the
'hand-made' aspect of each piece."[39] The precision of
sculptural form was matched by mechanical exactness.
Referring to François-Xavier's works as if they were made
jointly with Claude, British-American John Russell, then
an art critic at the *New York Times*, asserted: "If they make
a bath and wash basin in the form of a rhinoceros, neither
component will leak. If they make a safe in the form of a
gorilla, you can turn the key without a moment's anxiety."[40]
 While François-Xavier's early sculptural production
often involved works that contained a hidden function (more
for humorous or ironic affect than for true practical use)[41],

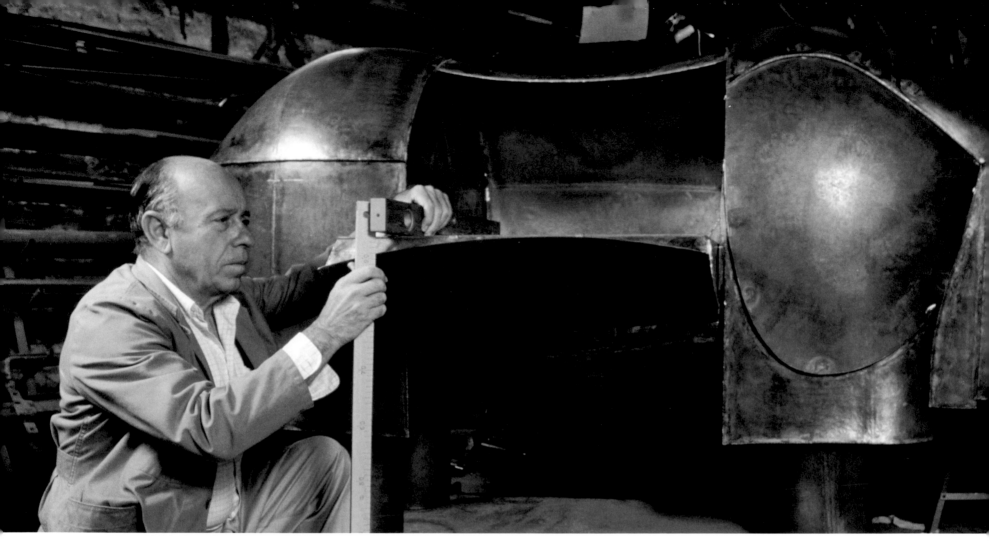

FIG. 12
François-Xavier Lalanne measuring
Grand Rhinocéros V (cat. no. 2) in his
workshop in Ury, France, September 16, 1991.

beginning in the early 1980s he concentrated more on pure
sculpture, focusing on his talent for refining the form of
animals to their essence, as with his 2005 *Singe Avisé* (Wise
monkey, fig. 13), a streamlined primate that gazes intently and
resolutely away from us. François-Xavier's love of animals was
evident throughout his career. In 1990 he asserted: "Animals
have always fascinated me, perhaps because they are the only
beings through which we can enter into contact with another
world."[42] As Claude would also do, he often made versions of
the same model, from "petit" to "très grande" or even "géante"
(giant). François-Xavier would sometimes revisit earlier

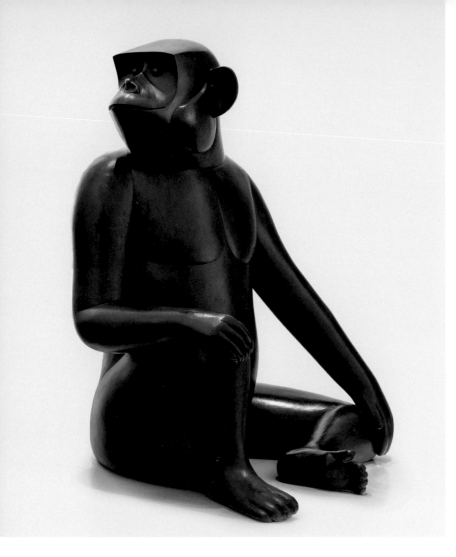

FIG. 13
François-Xavier Lalanne, *Singe Avisé (Grand)*, 2005.
Patinated bronze, 47 ¼ × 33 ⅜ × 30 ¾ in. (120 × 84 ×
78 cm).

ideas but remove the original function, such as with his 1972
Grande Carpe (Large carp), which had panels in its sides that
folded down, turning the fish into a table or desk; these panels
disappeared in the later *Carpe* (made in "grande" as well as
"très grande" sizes), which became a supernatural garden
sculpture—the quintessential fish out of water (cat. nos. 10
and 11). Throughout his career, he converted familiar animals
into irresistible yet mysterious creations, often playing on the
human instinct to tame or befriend animals, while maintaining
the sense that animals remain in their own inner worlds
that have little to do with our concerns. In 2016 collector
and curator Jérôme Neutres reflected on the attention both
François-Xavier and Claude brought to the animal kingdom in
their work, noting how they "explore the infinite fiction of the
human gaze on the animal."[43]

Claude rarely drew plans for her works, although she
did make a series of drawings for an article published in the
summer 1970 issue of the *Paris Review* based on some of her
famous works of flatware, jewelry, and fashion accessories
(fig. 14).[44] Her early works are primarily life-size in scale,
based on natural objects galvanized in her baths or cast in
bronze and then combined on a trial and error basis until
she achieved the effect she sought. The boldness of Claude's

experimentation with the galvanic baths is revealed in her 1964 *Marcassin*, for which she created a galvanic imprint of the beast by submerging a stuffed animal carcass in the electric current, later burning out residual matter within the copper shell and filling it with brass, then hand-finishing the surface and covering the sculpture with galvanized leafy vines.[45] Later in her career she began working on a larger scale, for example taking her *Choupatte*, which originally was galvanized from a real garden cabbage and real chicken feet, and expanding it in size through modeling and casting components in bronze, retaining the sense of familiar natural forms but exploring a disorienting scale (cat. nos. 3 and 18). From the beginning of her practice, she created sculptural components without any specific idea of how she might eventually use them. Rather than beginning with a finished concept in mind, she described experimenting with an object until it felt right to her: "Whether it's a small piece of jewelry or a large-scale sculpture, the work is the same. What matters is the form and what it inspires in me. It isn't a success until I find it beautiful, which is a rare and instantaneous reaction. It's there or it isn't, there is no other way."[46]

As novelist and playwright François-Marie Banier expressed in 1974, Claude's studio existed in a state of "chaos before creation."[47] She kept stockpiles of raw and partially realized materials, including stacks of cast and galvanized cabbage and other leaves in various sizes, galvanized and cast branches, vines, and vegetables, casts of field mice and animal and human body parts, and pigeonholes filled with scraps of metal in all sizes and shapes, all forming an inventory of possibilities awaiting the moment of inspiration (fig. 15). As she worked, she might choose any of these components to join together. Her techniques included galvanizing objects in her electric-current baths, in which natural materials took on new and strange forms, as well as

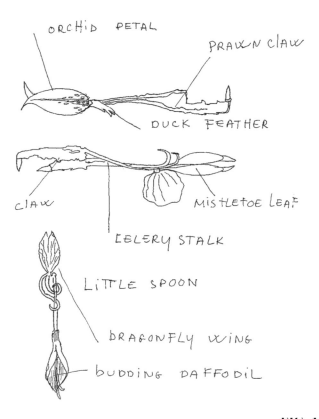

FIG. 14
Claude Lalanne, drawings for *Paris Review*, summer 1970.

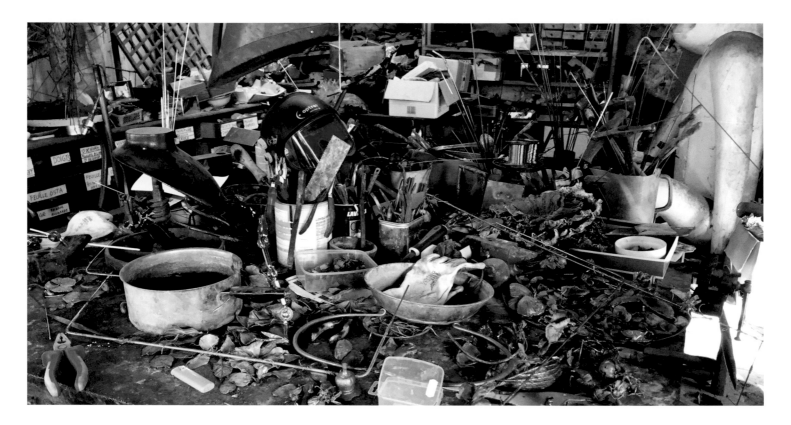

FIG. 15
Claude Lalanne's studio in Ury, France, March 11, 2019.

casting, cutting, welding, hammering, patinizing, soldering, filing, and chasing. In what has been seen as the opposite of François-Xavier's calculated process, Claude relied on improvisation and inventiveness in the moment. Regarding the jumble of components stored in her studio for years at a time, she said, "What the meaning is, I never know until it surfaces forth from the objects, perhaps years later . . . as if one had to wait for the moment of true encounter. One cannot rush the dialogue with objects."[48]

Not all of Claude's motifs came from the gardens and woods around her house. Her 1972 acquisition of a small stuffed crocodile from the Jardin des Plantes in Paris inspired a series of surreal chairs and tables (for example, see cat. no. 9). Her interest in creating objects on a human scale, such as jewelry formed from leaves and blossoms, persisted throughout her career, but she was not intimidated by the challenge of expanding that vision. Between 1974 and 1985 Claude created a series of fourteen large-scale mirrors for the salon of Saint Laurent's apartment on rue de Babylone in Paris (fig. 16), forming an atmosphere of beauty and abundance; the mirrors in their elaborate frames reflect the sculpture, furniture, and objets d'art scattered

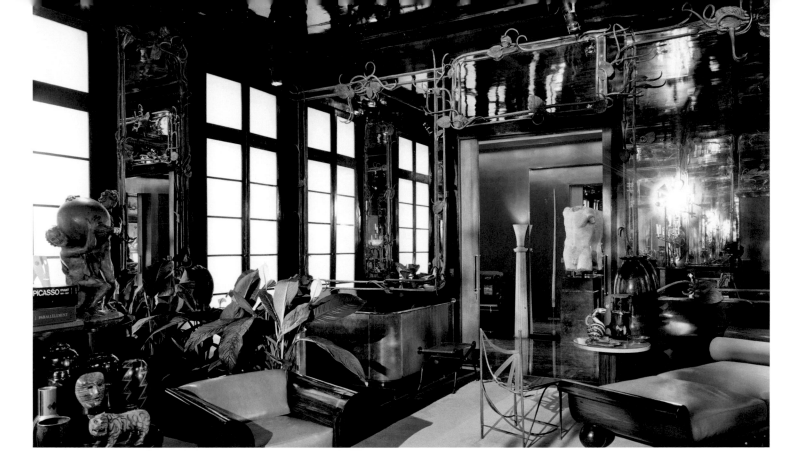

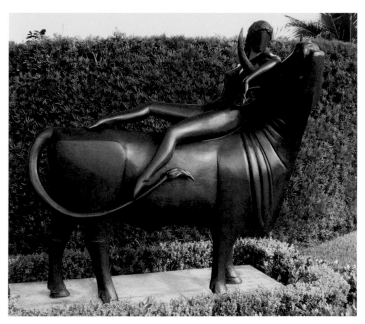

FIG. 16
The salon in the Saint Laurent-Bergé apartment,
with Claude Lalanne's fourteen mirrors, 1974–85.

FIG. 17
Claude Lalanne, *L'Enlèvement d'Europe*, 1990. Patinated
bronze, 79 3/8 × 31 1/4 × 79 in. (201.6 × 79.3 × 200.6 cm).
Private collection.

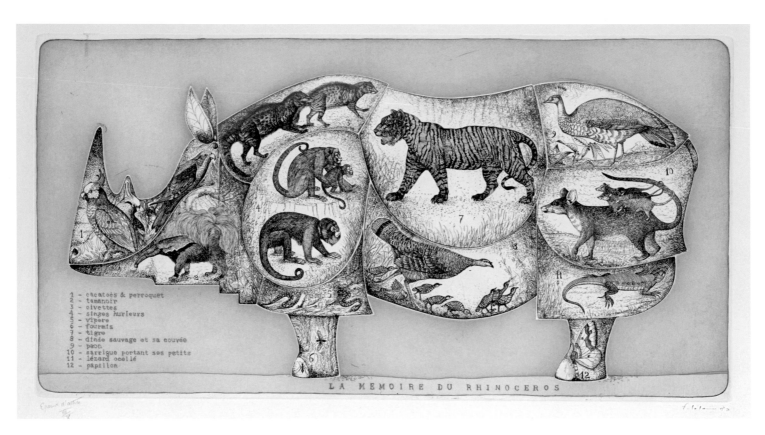

FIG. 18
François-Xavier Lalanne, *La mémoire du Rhinocéros*,
1980. Etching and aquatint, 19¾ × 26 in. (50.2 × 66 cm).

around the room (including other works by Les Lalanne). Other large-scale work included gates, staircase railings, and chandeliers, along with a few monumental sculptures, such as her Art Deco–reminiscent *L'Enlèvement d'Europe* (Rape of Europa, 1998, fig. 17), which was first shown at the Kaohsiung Sculpture Festival in Taiwan, and her series of *Pommes* (Apples, beginning in 2005).

The first example of a new work by both artists was typically a unique handmade object, which they sometimes returned to later for the creation of limited editions, often cast. For example, François-Xavier made the first *Mouflon de Pauline* (Pauline's mouflon, 1993) for friend and collector Pauline Karpidas, and later created a small number of casts for other clients (see cat. no. 15). Only a few works were produced in larger numbers, notably the *Moutons de laine* (see cat. no. 4), the *Pomme Bouche* (Apple mouth, the first dating to 1968, see cat. no. 6), and a few works made in partnership with production firms (such as François-Xavier's *Pigeon* lamps, made with Artcurial in an edition of 900 in 1991). Both artists returned throughout their careers to early ideas—for François-Xavier, the rhinoceros remained central to his artistic output. In addition to returning to the

full-size metal rhinoceros several times over the course of his career, François-Xavier also made a set of modular upholstered rhinoceros chairs for Daedalus Concepts in 1971, created a series of small rhinoceros sculptures, some of which open (see cat. no. 14), explored the rhinoceros in works on paper (fig. 18), and mounted an exhibition bringing together all his creations on the topic in 1980.[49] A wide variety of bird species portrayed at varying scales—from life-size to gigantic—was another favorite theme of François-Xavier's. Claude's early works also foretold consistent themes throughout her career. She returned to the form of the young wild boar encased in vines on several occasions, and in particular explored the potential of the *Choupatte*, which she created in a variety of sizes and patinas. On rare occasions the artists worked together, as when they collaborated on the monumental sculpture *Le Grand Centaure* (The large centaur) in 1985, for which Claude created the creature's human torso and arms and François-Xavier made the animal body and legs (fig. 19), or the late *Singe aux Nénuphars* (Monkey with lilies, 2007), a table in which the base, in the form of a monkey, was designed by François-Xavier while the tabletop of water lily leaves was created by Claude (cat. no. 19).

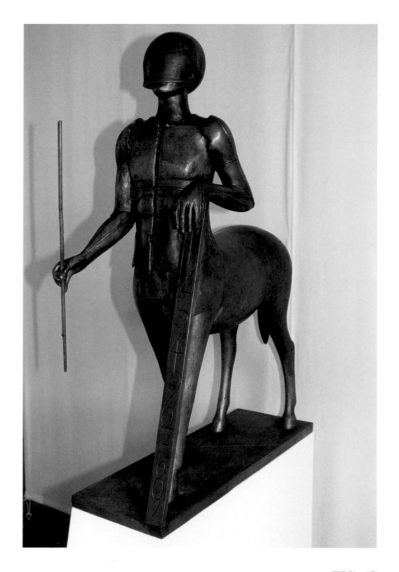

FIG. 19
Installation view of Claude and François-Xavier Lalanne, *Le Grand Centaure*, c. 1985, in *Sculptures by Claude and Francois-Xavier Lalanne at the Chateau de Chenonceau*, 1991, Chateau de Chenonceau, Chenonceaux, France.

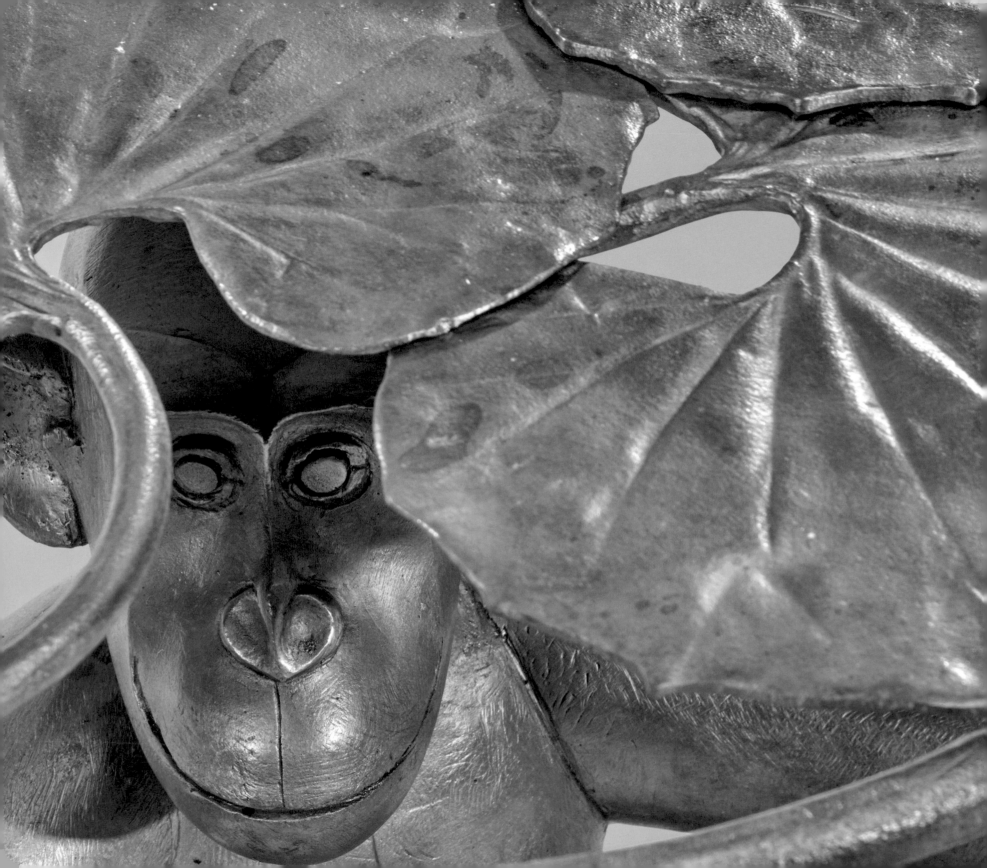

"Their . . . activity was partly shared, partly not. They remained separate individuals, with separate notions of how best to go to work."

JOHN RUSSELL, 1975[50]

ARTISTIC PARTNERSHIP

A deeper reflection on the unique working partnership of the couple and the significant ties between their biographies and their artistic productions is in order. While they were not the only pair of married artists who were prominent in the twentieth century—other examples include Sonia Delaunay and Robert Delaunay or Niki de Saint Phalle and Jean Tinguely—they are the only couple that regularly exhibited together under a single name even though they each had a separate practice. The extent to which the artists maintained their joint identity throughout their careers is striking. When François-Xavier told a reporter in 1966 to call his *Moutons de laines* "Lalannes,"[51] he was at once eschewing categorization of the works and creating a new term with which to identify all creations by the two artists, whether made by him, by her, or jointly. In early articles about the Lalannes, there are times when each artist is specifically mentioned as the creator of his or her own work, but just as often they are referred to together, with references to the rhinoceros bar or jewelry that "they" made.[52] At times their names appear to be seen as almost interchangeable, as in the catalogue of the 1971 Bienal de São Paolo, in which the text describing the display in the area devoted to French art mentions only François-Xavier's name, while the index of artists lists

only Claude's, and her name is also listed as recipient of an "honorary mention,"[53] whereas Lalanne biographers identify François-Xavier as the one to have achieved that distinction.[54] While they did exhibit and publish works under their own names at times, their affinity to the joint term endured. Toward the end of her career, Claude reflected on its proper use—"Les Lalanne," she pointed out, refers to the two artists themselves, while "Lalannes" refers to their creations.[55] Their presentation as a couple operating as a unit, without rank or distinction, stands as an anomaly among gender practices of their time. Nonetheless, gendered language does enter into the descriptions of their individual work when they are so identified, with François-Xavier presented as the dominant figure, more active and precise in his work, and Claude's work often described (even by François-Xavier) as belonging to an elusive "feminine" realm of feeling and intuition. These distinctions relate as much to the different working styles of the two artists as to the characteristics of their separate productions, but the reality is more complicated.

For the most part their oeuvres were separate but mutually sympathetic, and there are times when one can clearly see how each influenced the other, as with Claude's serene sculpture *La Dormeuse* (The sleeping woman, first made in 1974, with a later example featured on the cover of *L'Oeil* in 1995, fig. 20A), which in form is strikingly similar to François-Xavier's fountain-sculpture *La Pleureuse* (The

FIG. 20A
Claude Lalanne, *La Dormeuse*, on the cover of *L'Oéil*, November 1995.

FIG. 20B
François-Xavier Lalanne, *La Pleureuse*, 1986. Botticino marble and plants, 61 ¾ × 48 ½ × 19 ¾ in. (157 × 123 × 50 cm). Hakone Open Air Museum, Japan.

crying woman, first designed in 1974, fig. 20B). François-Xavier's example likely encouraged Claude to expand her work to a larger-than-life scale, ultimately leading, in 2016, to her enormous *Choupatte Géante* that stands nearly six feet tall, about which she said, "I think my husband would have been rather amazed by it."[56] François-Xavier made a drawing of a crocodile for Claude, which she used for inspiration to make *La Femme du Crocodile* (The crocodile's wife, 2012, fig. 21), a sculpture with a concealed bench. Claude modified her husband's drawing, adding a prehistoric spine to the creature and distorting its snout, saying, "it's not really a crocodile but something more diabolical."[57]

Their production methods, as well as their finished products, are closely linked with their personal stories. François-Xavier's first wife was Eugénie Pompon, a Dior model and remote relative of the great animalier sculptor François Pompon, whose simplification of form has echoes in François-Xavier's work. He was keenly interested in Pompon's work and mentioned it frequently, as recalled by his friend André Mourgues.[58] This association, along with François-Xavier's early friendship with Brancusi, experiences with the animal sculptures at the Louvre, and family background with sleek automobiles (his father owned a Bugatti) and cow-bone fertilizer (his grandfather became wealthy by importing cow bones to be crushed for fertilizer),[59] must be counted as important influences on the development of his subject matter and style. For Claude, one wonders whether when Metcalf suggested they explore the old-fashioned technique of galvanoplasty, he knew that she was born on the rue Galvani, called such after the namesake of that technique. Her father's interest in the archaic pseudoscience of alchemy also finds echoes in her production—rather than seeking the philosopher's stone by turning base metals into gold, she found ways to transmogrify

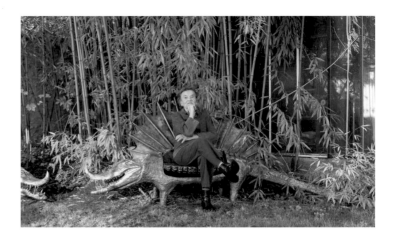

FIG. 21
Claude Lalanne sitting on
La Femme du Crocodile, 2015.

nature itself from the familiar to the hallucinogenic. Claude's practice remained closely tied to her personal relationships—she made sculptures based on the life casts of the heads and bodies of family and friends, sometimes naming her sculptures for them, such as the *Pomme Bouche d'Alan* (Alan's apple mouth, 2009/10, cat. no. 6). For François-Xavier, these relationships were also important. He dedicated works to close friends, such as the *Mouflon de Pauline* (cat. no. 15).

The Lalannes were outgoing people with a wide circle of friends and a busy social life, yet they were also notoriously hardworking. There existed seemingly no boundaries between their work lives and their personal lives—it was all one and the same. Their relationships with each other, their gallerists and friends, and the natural world form a unity that adds to the appeal of their creations. Their work reflects their personalities and their lived experience in a very direct way, but also communicates a timelessness grounded in a shared human experience of nature.

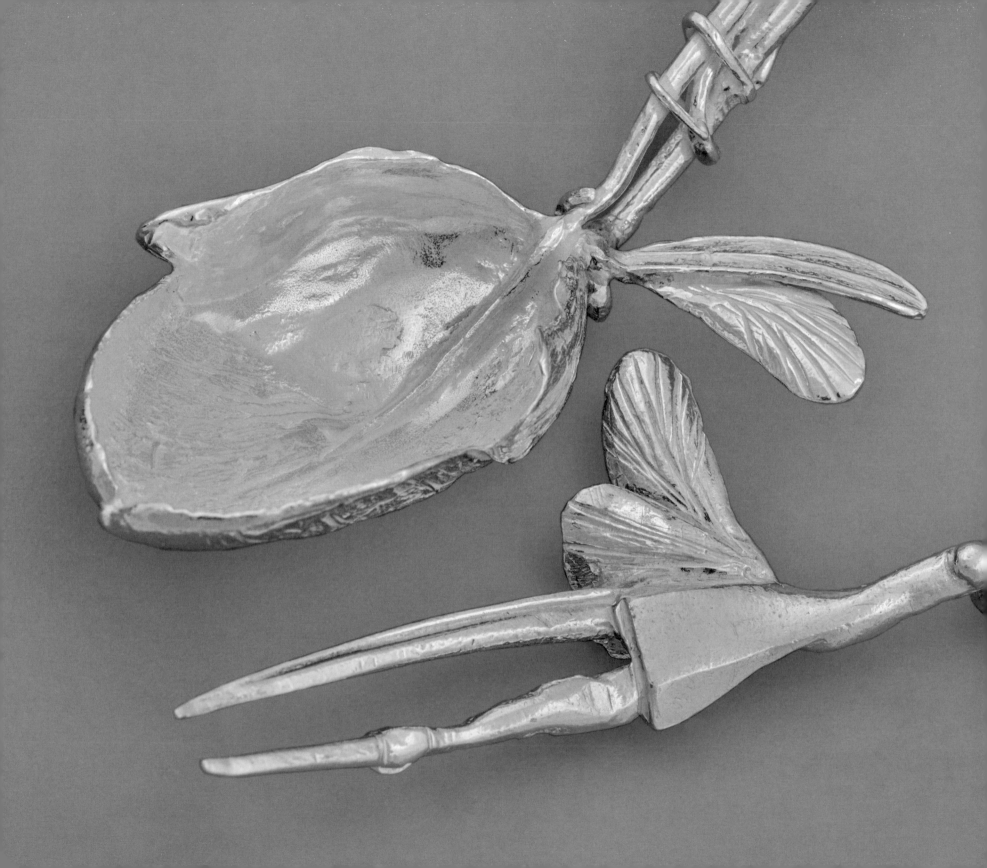

NATURE TRANSFORMED

All the works included in the Lalannes' first show, *Zoophites*, feature animals and vegetables that had been altered or combined in surprising ways, and this remained a central theme throughout their careers. The works included in the Clark's exhibition all reflect this lifelong fascination with reforging natural forms into things strange and new. Their varied approaches to the theme of transformation are explored further in the Catalogue section (pp. 67–109). In 1966 François-Xavier spoke to poet and writer Jérôme Peignot of his early interest in the kinetic, and particularly Alexander Calder's mobiles, saying, "what I like about them is their life." He said this led him to the idea of "transformation," and he created a set of tables that rotated around each other to form multiple configurations. From this, as he explained, he moved on to the *Moutons*. While conceding that these are not kinetic, François-Xavier asserted that randomness is an integral part of their poetry.[61]

François-Xavier's transformations usually involved reimagining an animal with a new, often hidden and ironic purpose. Many of his functional objects can be seen as fully formed sculptures when closed, sometimes with little hint that they are anything beyond that. It is the surprise of the transformation—the discovery of the function upon opening

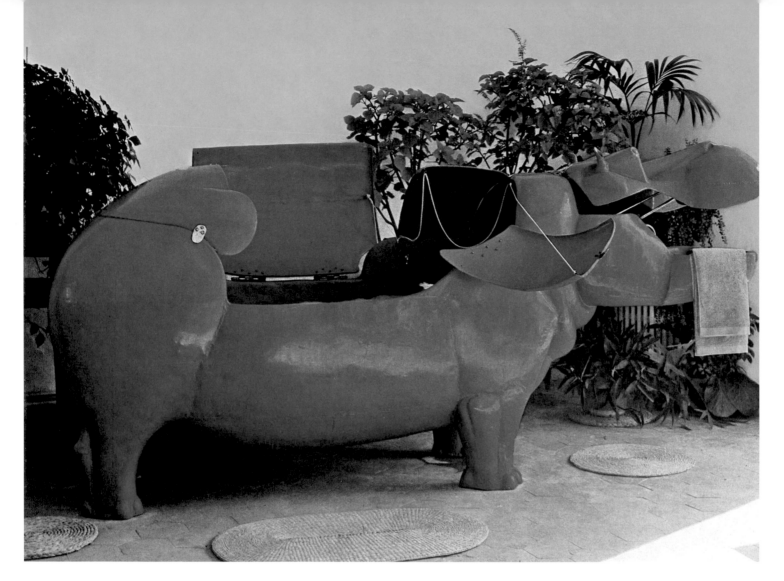

FIG. 22

François-Xavier Lalanne, *Hippopotame I*, 1968–1969.
Polyester resin, copper, iron, 70 ½ × 110 ¾ × 33 ¾
(179.1 × 281.3 × 85.7 cm).

a lid or door—that matters as much as or more than whether the object was ever actually used. His humor came through in many of his creations, whether it be a hippopotamus that, rather than lying semi-submerged in a pool of water, opens up to become a bathtub (fig. 22) or a duck whose waterproof wings become the protective roof of an imagined water taxi or party boat (fig. 23; cat. no. 13). Reinforcing the idea that putting these works to actual use was not the point, François-Xavier said of his hippopotamus tub: "It's possible to get so fond of it that one no longer has the slightest desire to bath[e]!"[62]

Claude's works represent both literal and conceptual transformations. The natural objects (or their molds) that she suspended in her baths were physically transformed into metal, resembling the original object but with a new and strange skin that she further manipulated once she removed it from the current. From galvanized and cast components, Claude invented a universe of semi-animate creations: a loaf of bread with feet, a snail shell with a finger poking out, and humans with cabbage heads, among others. These alterations sometimes took a frightening turn, as with *Hommage à Magritte* (Homage to Magritte, 1978, fig. 24), a pair of baby feet cast in bronze from molds taken from one

FIG. 23
François-Xavier Lalanne, *Canard-bateau*, 1975.
Graphite on paper,
9 ¼ × 9 ¼ in. (23.4 × 23.4 cm).

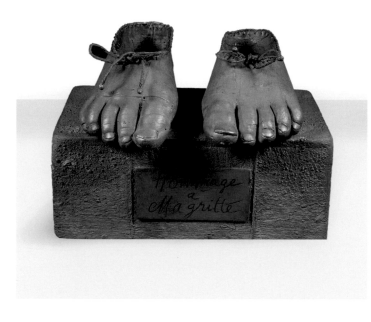

FIG. 24
Claude Lalanne, *Hommage à Magritte*, 1978.
Galvanized copper, 4 ³/₄ × 6 ⁷/₈ × 4 ³/₈ in.
(12 × 17.5 × 11 cm).

of her grandchildren, which appear as hollow skins trimmed with leather ties like moccasins.

In addition to rendering familiar objects strange through changes in form or function, the theme of transformation appears in the Lalannes' works in other ways, as with François-Xavier's *Moutons de laine*, which not only transform sheep into chairs, but also, as the artist described, bring the country into the city. At times the transformation found in their works is one of scale, expanding the size of animals, fruits, and vegetables to enormous proportions. Playing with scale and contrasts between what is visible and hidden, expected and unexpected, their works challenge us to stop and think in new ways about everyday things.

François-Xavier loved neologisms and combining words and images, as is evidenced in his book of poetry and lithographs titled *Polymorphoses*, which was published in a limited edition in 1978. In his juxtapositions within this book, the themes that appear in his sculpture, along with those by Claude, take on new meanings. He imagines Claude's *Choupattes* roaming over pastures and speaks of a world where vegetation is mobile and animals are fixed to the ground, while in another print, Claude's *Pomme Bouche* rises in place of the moon alongside the text, "The moon

is full, as is the apple" (fig. 25).[63] François-Xavier's poems and prints, along with the title of his book, suggest that the transformations embedded in their works are potentially endless.

This agility and playfulness with words also influenced object titles and terms employed by the Lalannes, reinforcing the multiple associations of their works. One object in the 1964 show at Galerie J, listed in the catalogue as a watch, was titled *Pléonasme*; possibly it was another onion-shaped watch in which the title points to the repetition of form and object ("pleonasm" refers to the use of more words than required to make a point). Whatever form the object took, the title is mildly self-mocking, a knowing reference to the tricks the artists were playing with nature. Along the lines of *Zoophite* and *Polymorphoses*, another term employed by Les Lalanne is worth mentioning: "phagocyte." In 1991 both François-Xavier and Claude editioned a series of works for Artcurial, promoted in a publication with designs and artist interviews.[64] François-Xavier designed porcelain tableware and a silver coffee service set that he labelled *Silhouettes*, a straightforward description of the style of decoration involved, while Claude created a series of tableware—knives, forks, spoons, and serving pieces—that she called *Phagocytes*.

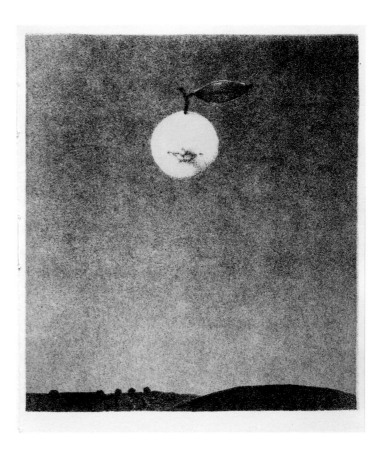

FIG. 25

François-Xavier Lalanne, *Untitled*, from the series *Polymorphoses*, 1978. Lithograph, 21 1/16 × 14 3/16 in. (53.5 × 36 cm).

As a scientific term, "phagocyte" refers to immune cells that encase foreign objects such as bacteria and dead cells, destroying them and thereby keeping the body's tissues clean and healthy. In popular use in French, to "phagocyte" is to devour a weaker entity, leaving not a trace behind. Claude's galvanic baths both destroy and create—the original object is obliterated by the process, revealing something different, a new object that is strong, lasting, and powerful.

Critics and biographers have pointed out the importance of the atmosphere the artists created at their home and studios in Ury. There, works of art were placed so that they could be seen from every vantage point, in the multiple buildings, yards, and gardens of the extensive compound (fig. 26). The presence of works by the Lalannes, indoors and out, created a magical trail of discovery, transforming the natural surroundings into a backdrop for their nature-inspired art. This seamless combination of the Lalannes' home and studio with nature and art embodied the assertion Metcalf made in the 1964 Galerie J catalogue that this is an art "pour vivre avec," to live with.[65]

FIG. 26
Claude and François-Xavier Lalanne's
home in Ury, France.

"*[Museums] don't know where to put us.*"

—FRANÇOIS-XAVIER LALANNE, 1998[66]

"*For us classification is of absolutely no interest but if forced to, we would say that, yes, we make sculpture.*"

—CLAUDE LALANNE, 2006[67]

CLASSIFICATION AND RECEPTION

Despite the evident success of these artists across their full careers, there is a sense that just in the past ten years Les Lalanne have begun to be awarded the recognition they deserve. This belated appreciation stems from several sources. The artists emerged in the mid-1960s as figurative sculptors at a time when abstraction was the dominant artistic mode. They made their own works, often using tools associated with blacksmiths or mechanics rather than using the expected artistic implements of paintbrush and chisel, which for some pushed against the idea of an artist as a thinker rather than a doer. And perhaps the biggest challenge was that of classification—where did their work fit in the recognized categories of art?

A reviewer of their 1966 Iolas gallery exhibition posed the question, "Are these works sculptures, decorative objects, works of art, intellectual entertainment, or gadgets?"[68] From the beginning of their joint career as exhibiting artists, this inability to find a suitable description of just what the Lalannes were producing has been a leitmotif. They have been called "unclassifiable," their works landing somewhere between sculpture, decorative arts, and design. These questions have affected the museum world in particular. The Lalannes' dealers, first Alexander Iolas in

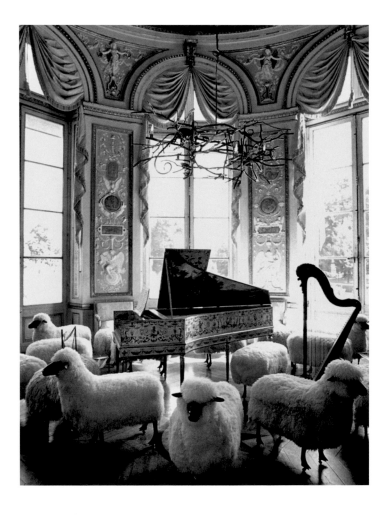

Installation view of François-Xavier Lalanne,
Moutons de laine in *Les Lalanne à Bagatelle*, Parc de
Bagatelle, Paris, March–August 1998.

Paris, New York, Milan, and Geneva, and now Jean-Gabriel
Mitterrand in Paris, Ben Brown in London and Hong Kong,
and the late Paul Kasmin in New York, have all directed
firms that primarily represent painters and sculptors, and
see no conflict in representing the Lalannes, although
Iolas once remarked that his taking on the Lalannes raised
some eyebrows at the time.[69] While their works are now in
countless private collections around the world, they are in
relatively few museum collections. The Museum Boijmans
Van Beuningen in Rotterdam acquired one work each by
François-Xavier and Claude after the 1975 exhibition shown
there, but outside France that action has been the exception.

Uncertain how to categorize them, museums have also
been slow to mount exhibitions of their work. Following the
bold decision to feature them in 1967 at the Art Institute of
Chicago, works by Les Lalanne appeared in a number of other
museum-organized exhibitions, though more frequently
in a number of commercial gallery shows around the world.
Important museum exhibitions devoted to the artists include
those in Edinburgh in 1974, Paris and Rotterdam in 1975,
London and Agen in 1976, the Loire Valley in 1991, and Paris
in 1998 (fig. 27) and 2010.[70] These exhibitions are important
markers in the history of the Lalannes' reception.

In the brief, celebratory overview of the Lalannes written by American art historian and curator Robert Rosenblum for the catalogue of a large exhibition of their sculpture shown at the Château de Chenonceau in the Loire Valley in 1991, he points to the myriad associations that can be drawn between their artistic practice and those of other canonical artists over a wide range of time, from antiquity up to the exhibition's present moment. He draws connections with some aspect of each of the following artworks or artists: ancient Egyptian and Assyrian sculpture; Renaissance engineer and craftsman Bernard Palissy; landscape architect André Le Nôtre; animalier sculptor Antoine-Louis Barye; the Art Nouveau movement in general (and Hector Guimard in particular); early twentieth-century architects and designers Josef Hoffmann, Charles Rennie Mackintosh, and Frank Lloyd Wright; Surrealist painter René Magritte; sculptor Pompon, painter and sculptor Fernando Botero; sculptor and performance artist Scott Burton; twentieth-century architects and designers Robert Venturi, Michael Graves, and Frank Gehry; and sculptor Claes Oldenburg. Marveling at the broad range of their practice, from intimate works for the dining table to monumental public sculpture, Rosenblum asserts, "the rational mind that insists on such tedious categories as painting, sculpture, and architecture and that would put every artist into the straitjacket of an 'ism' or a movement is overcome."[71] Or, as Russell summarized in 1975, "this is a complex art, one which mates Ancient Egypt with 'Alice in Wonderland,' zoology with cabinet-making, metaphysics with personal adornment. It is also an art of psychic equilibrium."[72] The Lalannes themselves professed on multiple occasions to be indifferent to categories and were ambiguous about the classification of their work. Of his original *Moutons de laine* François-Xavier proclaimed, "They are not furniture, they are not sculpture, just call them Lalannes."[73] A short essay by Gilbert Brownstone in the 1975 exhibition catalogue notes that François-Xavier and Claude opposed an elitist notion of "Art" and embraced the medieval concept of the "artisan," in which the work of painters and sculptors was seen as an occupation equal to any other.[74] Indeed, Claude was quoted on several occasions as saying that the words "artist" and "artisan" have the same meaning.[75]

In 1977 the Lalannes participated in the Musée des Arts Décoratifs exhibition *Artiste/Artisan?*. Curated by François Mathey, the exhibition explored the question of what distinguishes the artist from the artisan, publishing

texts on this topic from a wide range of sources, old and new. Contemporary artists' works were displayed alongside anonymous handcrafted objects from across time and around the world, such as an ancient Chinese steatite Pi disk, a sixteenth-century creche made with lampwork figures, and nineteenth-century wooden folk carvings. Among the many contemporary artists included were Alexander Calder, Christo, Sheila Hicks, Antoni Tàpies, and Claude, who exhibited *Caroline Enceinte* (Caroline pregnant, 1969, fig. 28). This life-size sculpture consists of galvanized and welded life casts of her daughter Caroline's pregnant form with a large galvanized cabbage in place of her head (it entered the collection of the Centre Pompidou in 1979).

François-Xavier contributed to the catalogue a series of provocative questions about the two terms, including:

- Can you be an artist and produce an artwork without being truly an artisan? Why?
- If an artisan becomes an artist, does he lose his status as artisan? Or the opposite?
- Can an artisan work with an artist without making art? How?
- Will a joint work conceived by an artisan and an artist, then executed by a laborer, be an artifact or half (or one-third) of an artwork?[76]

Although only a portion of the products of either artists have a function—whether desk, chair, lamp, mirror, or other object—the fact that many do has proven a stumbling block in the effort to define their art. For d'Elme, "sculpture is the category of handsome objects that are useless, while design is the category of a certain kind of functionalism that obviously excludes the Lalannes."[77] Ultimately, Claude tells us, the Lalannes thought of themselves as sculptors, but they also distanced themselves from what they considered "the kind of 'modern sculpture' which is overgrown, under-thought, and does nothing but sit there and wait to be admired,"[78] and instead made works that provide the viewer with a rich reward for stepping in to take a closer look, including perhaps looking inside. Not all critics saw the ambiguity of their creations as a problem: in 1973 d'Elme defended their creations, stating "It is not minor handicraft, but great art,"[79] and in 1975 the influential Vienna-born critic and writer Otto Hahn wrote, "Should they be called sculptors, craftsmen, decorators, poets? Probably all of the above."[80]

From early in their career, the Lalannes enjoyed positive reviews. François-Xavier was singled out by several critics as representing the most successful of exhibitors in the 1965 and 1966 Salon de la Jeune Peinture, including Roditi[81] and

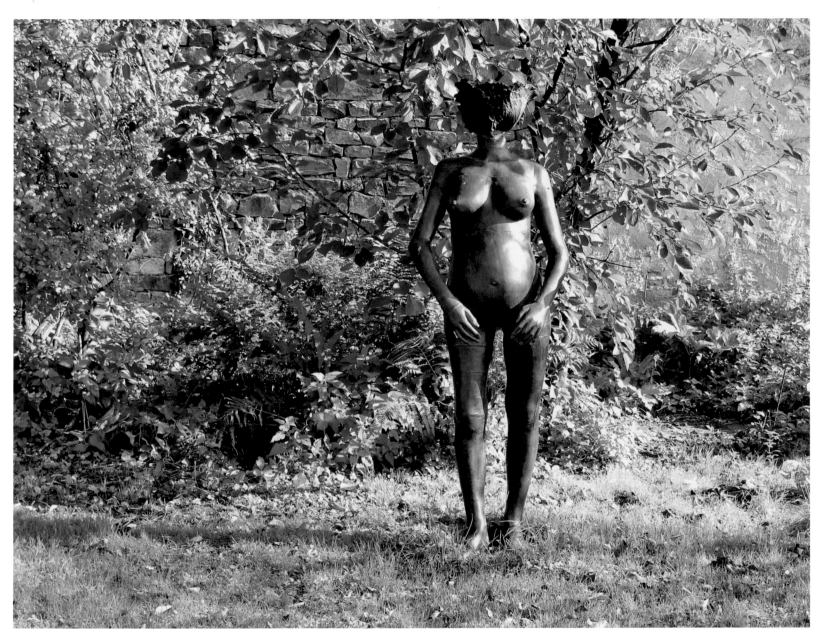

FIG. 28
Claude Lalanne, *Caroline Enceinte*, 1969. Bronze,
63 ¾ × 20 ½ × 15 ¾ in. (162 × 52 × 40 cm).

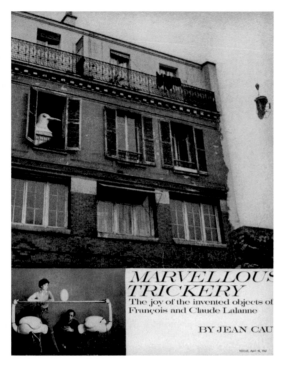

FIG. 29
Title page of Jean Cau, "Marvellous Trickery,"
published in *Vogue*, April 1967.

Hahn, who called the *Moutons de laine* "the most amazing
thing in the show."[82] At times the early critics reflected on
the extent to which works by Les Lalanne brought a different
spirit to Parisian displays of art. In an article that previewed
the show at the Galerie Alexandre Iolas in Paris in fall 1966
and the Alexander Iolas Gallery in New York the following
spring, Peignot contrasted the work of the Lalannes with that
of certain other artists active at the time who "protest against
the horror of the world that oppresses them," asking, "is it truly
indispensable to show so much rage?" Quoting François-Xavier
in an example of the artist's witty wordplay, he points to the
Lalannes not as "demolishers" but as "molishers,"[83] artists who
build up rather than tear down the world around them. Another
early article on the artists notes the non-polemical nature of
their work, commenting that they have no "axe to grind."[84]

A lengthy article on Les Lalanne written by controversial
journalist, writer, and intellectual Jean Cau appeared in
the April 1966 Paris and April 1967 New York editions of
Vogue.[85] Cau, who had been secretary to Jean-Paul Sartre
and was awarded the prestigious Prix Goncourt in 1961,
was delighted with the sensorial experiences of visiting the
Lalannes at their studio and home at the Impasse Robiquet
(fig. 29) and was equally captivated by the outrageous

imagination evidenced in their work. Noting a contrast to what he saw as the obfuscating prose of many artists,[86] Cau admired François-Xavier's refreshingly forthright talk, about which he wrote, hopefully, "I foresee in it the future of a critique of contemporary painting that will not balk at being lucid."[87] Ashbery, who filed one of the earliest reviews of their work, in 1964, wrote about Les Lalanne again in 1986 when an exhibition of their sculpture was shown at the Plaza of the Americas in Dallas, saying that their work "creates a delicious oasis in time and space during which we can reflect, briefly and without effort, on the enigmas concealed behind such seemingly mundane categories as practicality and art for art's sake."[88]

Although early press was positive, not everyone looked upon their work favorably. In October 1966 François-Xavier commented that he felt the cold shoulder of fellow artists with whom he had exhibited earlier in the year at the Salon de Mai in Paris. He pointed to the Surrealists in particular (many of whom had been his friends), who he claimed had become "very conservative."[89] More than twenty years later, François-Xavier looked back at this time and reflected, "it was just the end of the abstract period, which was still clashing with the École de Paris art. It was not possible

to think of useful art."[90] Claude also commented on their shared feeling of rejection by the mainstream art world: "Those who criticized our work said it was 'grotesque' because they felt sculpture should not serve any other purpose than to be looked at. The idea of sculptures that had a use was a complete nonsense."[91]

Despite the undeniable perception by the artists that their work was not well received by critics, outright negative published reviews are hard to find. When they surface, so do issues of classification. An early example appeared in the *Chicago Tribune* as a lead-up to the 1967 show at the Art Institute of Chicago. The headline reveals the skepticism of *Tribune* art editor Edward Barry: in "We Give Up! What Is Art?," Barry states, "If we thought we were making some progress toward finding an answer to the ancient question as to what art is, an exhibition due this week should set us back 20 years. . . . It will show the sculpture (or is it sculpture?) of a French husband and wife team."[92] Barry struggles to find a connection between the images he has seen of their work and his understanding of the "classical definitions of art." While he suggests that viewing the work once the exhibition opened might help clarify things, it seems he did not follow up this sensationalist teaser with an actual review of the exhibition.[93]

In 1973 the critic Pierre Restany, who had known the Lalannes' work from the start, given that he was the husband of Jeanine de Goldschmidt of Galerie J, published an article in *Domus* that provided a curious overview. Praising their inventiveness, their unpretentiousness, and their humor, he nevertheless made a cold prediction: "A new modernism (or another archaistic prejudice) will . . . drive them out of the bourgeois drawing-rooms which they entered by way of an erratic change of taste from Italian or Scandinavian design. They will end up in the flea markets, before being discovered once again by some future generation of enlightened amateurs."[94] Restany's backhanded attribution of their popularity to an "erratic change of taste" and relegation of their work to the domain of the "enlightened amateur" may have been prompted by his taking sides with Jean Tinguely in a dispute that had arisen between Tinguely and François-Xavier.[95]

Restany's implication that those who collected works by the Lalannes were mere "amateurs" perhaps also stems from a pervasive social prejudice against the kinds of clients they attracted. With preexisting ties to the world of high fashion—having worked for Christian Dior, Yves Saint Laurent, Lanvin, and others early in their careers—Les Lalanne were quickly

taken up by the jet set, associations that were to prove at once rewarding and limiting. While François-Xavier had not made his first rhinoceros desk with high-end drawing rooms in mind, the truth is that a rhinoceros-size piece of furniture fits in few places. This absurdity is part of the point—these are sculptures masquerading as furniture. Nourissier, in his 1966 catalogue essay, points to the near uselessness of these "useful" objects: "Obviously, at the cost of a few scratches, you can eat (what a triumph!) with 'Lalanne' knives and forks. So what?"[96] That they found their way into the houses of the rich and famous bred resentment among some. Using as an example François-Xavier's *Grand Chat-polymorphe* (Large cat-polymorph, 1968, fig. 30), in 1970 novelist and art critic Gilbert Lascault criticized the extravagant uselessness of such creations: "Their party-animal cat-monster would shatter a functionalist apartment—it is too big, too shiny. It belongs to the realm of excess: unproductive, it consumes money and space, indicating a path that leads straight to intoxication."[97] Striking at a perceived lack of profundity in their work, he also claims that the hybrid cat sculpture inspires "a communion of friendship or snobbism, not one of mysticism."

A pointedly negative review was written in 1989 by critic and painter Lawrence Campbell for *Art in America* regarding

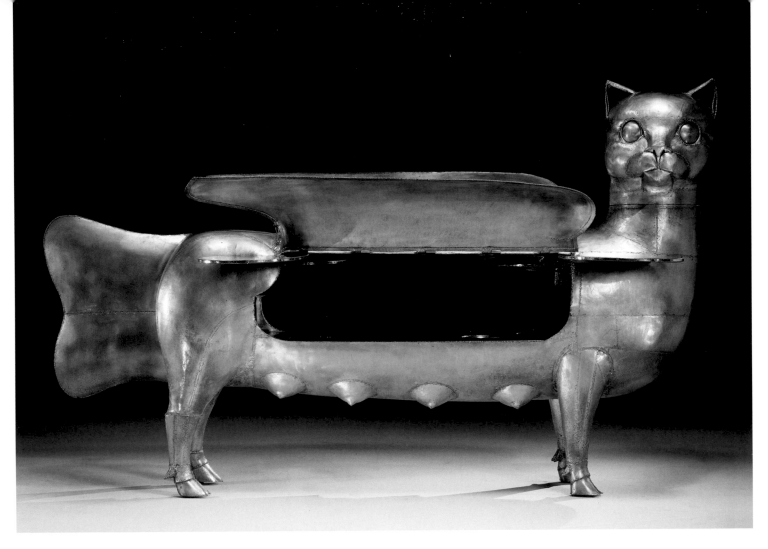

FIG. 30

François-Xavier Lalanne, *Grand Chat-polymorphe*, 1968.
Brass, 80 ½ × 138 × 23 ¾ in. (204 × 350 × 60 cm).

a show of Les Lalanne at the Marisa del Re Gallery in New York. He dismissed their work as "a somewhat chichi form of surrealism" and found it lacking in energy, unsatisfactory in technique, and shallow. He asserted that most of François-Xavier's works are "sculptures corrupted by usefulness."[98] Campbell's disdain for the Lalannes' brand of humor, which ultimately celebrates rather than condemns the world, is no doubt an opinion shared by many who have ignored their work. Others see their humor and inventiveness to be life-affirming, providing, in the words of one critic, a "metamorphosis where everything can arise."[99]

The literature on the Lalannes includes a number of catalogues from shows mounted by their gallerists over the years, many of which contain essays and other materials that help illuminate the artists' careers. The artists have also been the subject of several important monographs, sometimes published in connection with special exhibitions, such as the 1975 presentation at the Centre National d'Art Contemporain in Paris, which was organized by French curator and museum director Daniel Abadie. A book published in conjunction with the show includes an essay by Russell. Reflecting on an "unspoiled sense of poetry . . . and a high degree of technical achievement" in their work, he claimed that the Lalannes "bring white magic into the life of the everyday."[100]

In 1991 the Lalannes exhibited more than one hundred sculptures on the grounds and within the long gallery of the Château de Chenonceau. An accompanying publication included the essay by Rosenblum and a history of the Lalannes in the form of a detailed chronology by Abadie.[101] This chronology was translated to English, slightly revised, and brought up to date by Abadie in his 2008 monograph on the artists.[102] A monograph by French curator and museum director Daniel Marchesseau also appeared in 1998, accompanied by an extensive bibliography.[103] The

retrospective held at the Musée des Arts Décoratifs in 2010 featured an installation designed by architect Peter Marino and a catalogue with an essay by then-curator and current museum director Olivier Gabet, who reflects on how their long careers were at last being appreciated by the museum world.[104] Most recently, a 2015 publication edited by British artist, journalist, and curator Adrian Dannatt for Kasmin Gallery in New York provides a rich trove of information and images excerpted from early publications and exhibitions, along with commentary on the artists by dozens of their admirers; a 2018 monograph by Dannatt contains a thorough overview and insightful analysis of the Lalannes and their work.

Reacting to the 2010 retrospective, critic and curator Philippe Piguet pointed to the prolix oeuvre of the Lalannes, asserting "their resolutely hybrid way places them not on the margins but in the heart of postmodernity."[105] In his catalogue essay, Gabet speaks of the Lalannes as creating objects for an optimistic world.[106] The joy embedded in their work, the sense of humor, the irony without bitterness are seen by some as the artists turning away from the problems of the world and a need to interrogate them. But art that reminds us of the joy of living can also be seen as a much-needed gift. To quote French

FIG. 31
François-Xavier and Claude Lalanne, 2007.

journalist and writer Bernard Frank, "Fortunately, there
are the Lalannes, because their happiness gives us the sweet
illusion that we are still at home on this earth."[107]

The works created by these artists across six decades
form a large and inspiring oeuvre. Situated in gardens and
living rooms around the globe, we can predict that more and
more of their art will find its way to museum collections—as
with the *Rhinocrétaire II* from the 1966 Galerie Alexandre
Iolas show, which entered the collection of the Musée
des Arts Décoratifs in 2010 and is now a centerpiece of
their displays—making it possible for larger audiences to
appreciate it. The Lalannes remained committed to each
other and their art throughout their lives (fig. 31). The
natural world provided them with an unending source
of inspiration. It is therefore not surprising that their
sculptures work so well embedded in nature, as in elaborate
private gardens[108] or special displays at public botanic
gardens.[109] Their furniture and smaller sculptures bring the
world of nature into domestic spaces. Owners of these works
are understandably attached to them, reluctant to part with
them even for a short time. We are grateful to those collectors
who generously allowed the Clark to borrow works for this
show, enabling us to explore and celebrate the power of the
Lalannes' artistic imagination, their impressive command
of technique, and the enduring appeal of their life-affirming
creations.

NOTES

1 Daniel Marchesseau, "Accrochages en tous genres," *Les Nouvelles littéraires*, May 6–12, 1974, 16, quoted in Daniel Abadie, *Lalanne(s): The Monograph* (Paris: Flammarion, 2008), 315. All French-language citations quoted in Abadie appear there in English translation.

2 François Nourissier, *Les Lalannes*, trans. Conrad Wise (Paris: Galerie Alexandre Iolas, 1966), unpaginated.

3 The original term is "sculptures-calembours." Jérôme Peignot, "Lalanne," *Connaissance des Arts*, no. 176 (October 1966): 122. Unless otherwise noted, English translations of foreign-language sources are by the author.

4 Claude Bouyere and Marie-Claude Volfin, "Les Lallanne [*sic*] (Galerie Alexandre Iolas)," *Les Lettres françaises*, July 19, 1972, 26, quoted in Abadie, *Lalanne(s)*, 311.

5 Otto Hahn, "L'inventaire des Lalanne," *L'Express*, June 16–22, 1975, 28, quoted in Abadie, *Lalanne(s)*, 318.

6 John Russell, "The Lalannes," in John Russell and Gilbert Brownstone, *Les Lalanne* (Paris: SMI; Centre National d'Art et de Culture Georges Pompidou, 1975), 19.

7 Their work is held in only a few US art museums, including the Cooper Hewitt, Smithsonian Design Museum, New York; Costume Institute, Metropolitan Museum of Art, New York; and Philadelphia Museum of Art. In addition, an example of François-Xavier's sculpture *Génie de Bellerive* (Genius of Bellerive, 2007) was donated to the Norton Museum of Art in West Palm Beach, Florida, in 2016 (cat. no 17). In France, their works appear in the Centre Pompidou and Musée des Arts Décoratifs in Paris, the Musée des Beaux-Arts d'Agen (François-Xavier's hometown), as well as museums in Nice, Amiens, and elsewhere. Works by one or both artists are also held in the collections of the Museum Boijmans Van Beuningen, Rotterdam; Victoria and Albert Museum, London; Moderna Museet, Stockholm; and the Fondation Pierre Gianadda, Martigny, Switzerland.

8 The Art Museum of South Texas in Corpus Christi mounted a solo show of their work in 1977 (without a catalogue), and they have been the subject of a number of significant outdoor sculpture exhibitions. See pages 130–32 of this volume for a selected exhibition history.

9 Rainer Michael Mason, "Les expositions à Genève," *La Tribune de Genève*, October 15, 1971, 39, quoted in Abadie, *Lalanne(s)*, 308–9.

10 For those interested in learning more about these artists, the most comprehensive sources include Abadie's monograph *Lalanne(s)*; Daniel Marchesseau's book *The Lalannes* (Paris: Flammarion, 1998); the useful compendium *Les Lalanne: Fifty Years of Work, 1964–2015*, ed. Adrian Dannatt (New York: Paul Kasmin Gallery, 2015); and Dannatt's monograph *François-Xavier and Claude Lalanne: In the Domain of Dreams* (New York: Rizzoli International Publications, 2018).

11 Abadie quotes a 1998 interview with François-Xavier in which he recalls his time as a guard at the Louvre in late 1949/early 1950, including taking a "thousand mental pictures" of *The Apis Bull*. Abadie, *Lalanne(s)*, 295. In the 1975 exhibition catalogue, John Russell reports that François-Xavier frequently "took his siesta" on the sculpture's back. Russell, "The Lalannes," 21.

12 Russell, "The Lalannes," 21.

13 For references to their early design work, see Abadie, *Lalanne(s)*, 296; Jean-Louis Gaillemin, "Atelier Lalanne," *Architectural Digest* (February 1981): 113–14; and "Interview with Claude Lalanne," by Alain Elkann, Alain Elkann Interviews (February 2017), https://www.alainelkanninterviews.com/claude-lalanne/.

14 Dannatt includes an insightful quote from Claude about her collaboration with Metcalf on this learning process in *François-Xavier and Claude Lalanne*, 59.

15 Marchesseau writes eloquently about the expertise and subtlety of the processes of metalworking she perfected in *The Lalannes*, 31–32.

16 The opening date is printed on the cover of the exhibition's catalogue. The closing date is indicated in John Ashbery's review of the show in his longer article "Segui Shows Horrors in Double Paris Show," *New York Herald Tribune*, October 6, 1964, 5 (Paris edition).

17 Abadie notes that they made this decision prior to the 1966 Galerie Alexandre Iolas show. Abadie, *Lalanne(s)*, 302.

18 Ashbery, "Segui," 5. Ashbery praised François-Xavier's *Bar-rhinocéros* and likened Claude's *Choupatte* to a creature from a Hieronymus Bosch painting. The rhinoceros was also illustrated and favorably reviewed by André Ferrier, "Le mois du Blanc," *Le Nouvel Observateur*, January 21, 1965, 32–33.

19 Michel Ragon, "L'art modern exerce-t-il une influence sur le décor de notre vie?," *Jardin des Arts* (April 1965): 18-19.

20 Édouard Roditi, "Paris: The Occident Revisited," *Arts Magazine* 39, no. 6 (March 1965): 73.

21 "Avec lui, on rhinocéroce." François-Xavier Lalanne, quoted in Peignot, "Lalanne," 122.

22 François-Xavier's humor is evidenced by his explanation of the usefulness of this mechanical tortoise to a journalist. He explained, "It'll circulate among the guests, make the rounds, and if it comes to a guest it doesn't like, it will pull in its head." Quoted in Jean Cau, "Marvellous Trickery: The Joy of the Invented Objects of François and Claude Lalanne," *Vogue* 149, no. 8, April 15, 1967, 151 (New York edition).

23 Peignot, "Lalanne," 120-23; Gloria Emerson, "'They Art Not Furniture,' He Said, Sitting on a Sheep," *New York Times*, October 12, 1966, 46.

24 Pierre Bergé, "Claude et François-Xavier logent la poésie chez Alexandre Iolas," *Combat*, October 27, 1966, 9. An English translation of this article appears in Dannatt, ed., *Les Lalanne*, 29.

25 Otto Hahn enthused about the work in his review of the Salon de la Jeune Peinture, "Les Moutons de Lalanne" *L'Express*, January 24–30, 1966, 46, quoted in Abadie, *Lalanne(s)*, 298. See also Édouard Roditi, "Paris: The Winter's High Jinks," *Arts Magazine* 40, no. 6 (April 1966): 50; and Édouard Roditi, "Letter from Paris: Surrealism Resurrected," *Apollo* 83 (May 1966): 382.

26 René Barotte, "Les Lalanne qui sculptent pour la vie quotidienne," *Sud-Ouest*, November 29, 1966, 13.

27 Bill Wise, "Nothing like Creatures for Creature Comfort," *Life*, February 3, 1967, 76.

28 The details of the development of the Art Institute show as outlined here can be found in a series of files in the A. James Speyer papers, Institutional Archives, The Art Institute of Chicago (hereafter, AIC Archives).

29 *Sculpture by Claude and François-Xavier Lalannes*, March 7–April 2, 1967, was cocurated by Speyer and Allen Wardwell. A slim pamphlet was published, and the Art Institute repurposed the Galerie Alexandre Iolas catalogue, although the exhibition contents were not identical. More installation photography, a few studio shots of the *Moutons*, and a PDF of the Iolas gallery catalogue are available at https://www.artic.edu/exhibitions/4770/sculpture-by-claude-and-francois-xavier-lalannes.

30 The AIC Archives reveal that *Life* wanted to include reference to the Chicago show in their article, but the Art Institute did not receive authorization from the Iolas gallery and the Lalannes in time. The article makes no mention of the Art Institute of Chicago show.

31 An image of *Rhinocrétaire II* in Aillaud's home appears in Peignot, "Lalanne," 122-23.

32 See Jeanne-Marie de Broglie, "Lalanne Land," *Connaissance des Arts*, no. 454 (December 1989): 118-21.

33 The model for this project is illustrated in Abadie, *Lalanne(s)*, 326. The topiaries wound up at the Lycée Française de Los Angeles. See Dannatt, ed., *Les Lalanne*, 11.

34 Jacques Lassaigne, "França," *Catálogo da 11ª Bienal de São Paulo* (São Paulo: Fundação Bienal de São Paulo, 1971), 88–89, https://issuu.com/bienal/docs/name9839c4/82.

35 Claude Lalanne, interview by Dorothée Lalanne, in "Les Lalanne: Les Silhouettes et les Phagocytes," special issue, *AURA: Cahiers d'Artcurial*, no. 1 (April 1991). English translation in *Claude & François-Xavier Lalanne* (Paris: Societé Internationale d'Art Moderne; JGM Galerie, 2013), 9.

36 François-Xavier Lalanne, quoted in Nicholas Callaway, "Origin of Their Species," *Departures* (September 2007), 110.

37 "It's true that when I create animals, I always begin with a profile drawing as this is the simplest way of getting to the volume." François-Xavier Lalanne, "Les Lalanne," interview by Dorothée Lalanne, in *Claude & François-Xavier Lalanne* (2013), 6.

38 François-Xavier Lalanne, *Polymorphoses* (Paris: La Hune, 1978).

39 Patrick d'Elme, "The Story of the Lalannes," *Cimaise* (January 1970): 68.

40 Russell, "The Lalannes," 19.

41 In a review of the 1966 Iolas show, Jérôme Peignot said of the objects made by the Lalannes: "In the end, their usefulness is only a source of both poetry and irony," "Des cadeaux de non anniversaire," *Le nouvel observateur*, no. 102, October 26–November 1, 1966, 51.

42 François-Xavier, interview by Dorothée Lalanne, 5.

43 Jérôme Neutres, "On Another Planet," in *Claude & François-Xavier Lalanne* (Paris: Galerie Mitterrand, 2016), 16.

44 These drawings are reproduced in Dannatt, ed., *Les Lalanne*, 34–35.

45 The work was one of the few illustrated (without a caption) in the exhibition catalogue for the 1964 show at Galerie J, but does not appear in the catalogue's list of works as *Marcassin*, the title it was later given. In fact, until just before the exhibition, Claude had

planned to turn this sculpture into a clock, and created a precise hole to accept a round clock mechanism. As she explained to Patrick d'Elme in 1970, "the wild boar never got the clock he was destined to have ('in the end it didn't go with him')." d'Elme, "The Story of the Lalannes," 60. Knowing this, there is only one work listed in the 1964 catalogue that could be the boar, an object listed as a "pendule." It is interesting to note that the title is listed as *Hello Jim*—perhaps because the technical achievement of galvanizing an entire boar represents the most complicated of the works Claude showed in this first exhibition, the result of long periods of experimentation with the galvanic process undertaken alongside her friend James Metcalf.

46 Claude Lalanne, interview by Dorothée Lalanne, 9.

47 François-Marie Banier, "Une Forte Tête," *Elle* (January 1974): 108–9 (Paris edition). English translation in Dannatt, ed., *Les Lalanne*, 42.

48 Claude Lalanne, interview by Dorothée Lalanne, 9.

49 The exhibition *L'Rhinocéros dans Tous ses États* was shown at the Galerie La Hune in 1980. See Abadie, *Lalanne(s)*, 322.

50 Russell, "The Lalannes," 22.

51 Emerson, "'They Are Not Furniture,'" 46.

52 For example, in the article "Figurative Furniture: The Work of Claude and François Lalanne," *Harpers & Queen* (March 1971): 64–67.

53 Lassaigne, "França," 88–89; *Catálogo da 11ª Bienal de São Paulo*, 260, 268.

54 See Abadie, *Lalanne(s)*, 308.

55 Pierre Bergé, Peter Marino, Reed Krakoff, and Adrian Dannatt, *Claude and François-Xavier Lalanne* (New York: Reed Krakoff, Paul Kasmin, and Ben Brown, 2006), 9.

56 Claude Lalanne, quoted in Helen Chislett, "Claude Lalanne: Behind the Scenes with the Fabled Sculptor, Who Has Died Aged 93," *Financial Times*, April 11, 2019.

57 Claude Lalanne, quoted in Tobias Grey, "Next to Nature, Art," *Wall Street Journal*, June 20, 2013.

58 Private conversation between André Morgues and Olivier Meslay, September 23, 2019.

59 Dannatt, *François-Xavier and Claude Lalanne*, 28, 31.

60 Cau, "Marvellous Trickery," 151.

61 Peignot, "Lalanne," 121.

62 d'Elme, "The Story of the Lalannes," 60.

63 Lalanne, *Polymorphoses*, 3–6.

64 "Les Lalanne: Les Silhouettes et les Phagocytes."

65 James Metcalf, *François Xavier et Claude Lalanne: Objets* (Paris: Galerie J, 1964), unpaginated.

66 François-Xavier Lalanne, quoted in Eric Jansen, "L'oeuvre poétique de Claude et François-Xavier Lalanne," *Point de Vue*, no. 2588, February 25–March 3, 1998, 42.

67 Bergé, Marino, Krakoff, and Dannatt, *Claude and François-Xavier Lalanne*, 9.

68 François Pluchart, "De Raysse à Lalanne, Alexandre Iolas répond aux interrogations de la sensibilité actuelle," *Combat*, October 31, 1966, 7.

69 As recalled by André Mourgues in Adrian Dannatt, ed., *Alexander the Great: The Iolas Gallery, 1955–1987* (New York: Paul Kasmin Gallery, 2014), 70.

70 See a listing of major exhibitions of their work on pages 130–32 of this volume.

71 Robert Rosenblum, *Les Lalanne* (Geneva: Skira, 1991), 133–34. Skirting the issue of why their works are not better represented in museum collections, Rosenblum comments that their work "is at its best when it takes us by surprise in the form of a desk or a chair in somebody's living room or when it can unexpectedly transform a public site into a land where giants and elves may still be living," 135. This statement echoes John Russell, who in 1975 asserted that the Lalannes would "like to see their work put to use—preferably in a domestic situation—rather than roped off in a museum," "The Lalannes," 19.

72 Russell, "The Lalannes," 23.

73 Emerson, "'They Are Not Furniture,'" 46.

74 Gilbert Brownstone, "The Best Way to Explain It Is To Do It," in *Les Lalanne*, 81.

75 In 2017 Alain Elkann asked Claude if she considered herself an artisan. She replied: "Yes, sure, artists and artisans are the same thing. It is the same definition in the dictionary." "Interview with Claude Lalanne," Alain Elkann Interviews.

76 The questions are translated to English in Abadie, *Lalanne(s)*, 230. In the original exhibition catalogue, *Artiste/Artisan?* (Paris: Musée des Arts Décoratifs, 1977), they appear on page 105.

77 Patrick d'Elme, "Les Lalanne," *Mobile, Maison de la culture d'Amiens*, no. 17 (November 1973): unpaginated, quoted in Abadie, *Lalanne(s)*, 314.

78 Russell, "The Lalannes," 22.

79 d'Elme, "Les Lalanne."

80 Hahn, "L'inventaire des Lalanne," quoted in Abadie, *Lalanne(s)*, 318.

81 Roditi, "The Occident"; Roditi, "The Winter's High Jinks"; and Roditi, "Letter from Paris."

82 Hahn, "Les moutons de Lalanne," quoted in Abadie, *Lalanne(s)*, 298.

83 "Nous ne sommes pas des démolisseurs, explique joliment Lalanne en parlant de son travail et de celui de sa femme, mais des molisseurs," Peignot, "Lalannes," 122.

84 "Just Call Them 'Lalannes,'" *Interiors* 126 (May 1967): 16.

85 Cau, "Marvellous Trickery," 140–41, 145, 151. The same article, with different images and image captions, appeared one year earlier in the April 1966 French edition of *Vogue*, "Lalanne: Une imagination en délire, un bon sens colossal," 148–53.

86 "[T]oo many painters and sculptors and musicians and writers seem to have been endowed with speech only to spout gibberish that is designed to erect a screen of words before the nothingness of their work," Cau, "Marvellous Trickery," 151.

87 Cau, "Marvellous Trickery," 145.

88 John Ashbery, *Les Lalanne* (Dallas: Plaza of the Americas, 1986), inside front cover. It seems that Ashbery was commissioned to write the short essay for this slender twelve-page catalogue at the suggestion of the Lalannes. Warm correspondence between the Lalannes and Ashbery shows that they were pleased with his text, even if they were disappointed in the catalogue itself. François-Xavier wrote, "the catalogue is unfortunately a disaster and we are ashamed to have brought you in to this adventure." John Ashbery Papers, *97M-43, Box 26 (HH1KQN), Folder: Les Lalanne, Houghton Library, Harvard University, Cambridge, Massachusetts.

89 François-Xavier Lalanne, quoted in Patrice de Nussac, "Un taxi pour Lomé," *Paris-Presse*, October 22, 1966,

English translation in Abadie, *Lalanne(s)*, 298. In a similar vein, Jean Cau quoted François-Xavier declaring painters to be "pretentious chattering do-nothings," Cau, "Marvellous Trickery," 145.

90 François-Xavier Lalanne, quoted in Hunter Drohojowska, "This Pricey Menagerie Is More Fun Than Fine Art," *Los Angeles Herald Examiner*, July 13, 1986, E1.

91 Claude Lalanne, quoted in Kim Willsher, "Fantastique Beasts: Cult Art from the Lalannes' Private Collection to Go On Sale," *Guardian*, July 20, 2019.

92 Edward Barry, "We Give Up! What Is Art?," *Chicago Tribune*, March 5, 1967, E2.

93 The only other notice of the show I have found is "Furniture on the Hoof," *Chicago Sun Times*, March 19, 1967, 18–22, which seems to have been written without the reporter having actually seen the show, given that it includes among the works on view *Cocodoll*, which had not been ready for shipment and was not shown in Chicago, according to documents in the AIC archives, including final checklist, installation shots, and installation floorplan. The *Chicago Sun Times* article, which ran without a byline, claims the work has a "crazy logic."

94 Pierre Restany, "Les Lalanne ou le reve à la maison," *Domus*, no. 518 (January 1973): 38–41.

95 This dispute is summarized in Abadie, *Lalanne(s)*, 210–11.

96 Nourissier, *Les Lalannes*, unpaginated.

97 Gilbert Lascault, "Le luxe et la vie," *Paris-Normandie (Vexin-Mantois)*, January 23, 1970, quoted in Abadie, *Lalanne(s)*, 306–7.

98 Lawrence Campbell, "Claude and François-Xavier Lalanne at Marisa del Re," *Art in America* (February 1989): 166–67.

99 Marielle Ernould-Gandouet, "Les Lalanne dans la nature," *L'Oeil*, no. 434 (September 1991): 64.

100 Russell, "The Lalannes," 19.

101 Abadie is not credited for the chronology in the book, but notes his authorship in his 2008 monograph, 333. Adrian Dannatt identifies Abadie as the curator of the 1975 show. Dannatt, ed., *Les Lalanne*, 95.

102 Abadie, *Lalanne(s)*, 292–348. For additional chronology up to the year 2016, see *Claude & François-Xavier Lalanne* (2016), 96–101.

103 Marchesseau, *The Lalannes*, 147–51.

104 Olivier Gabet, "Les nouvelles Bucoliques," in Dominique Forest and Béatrice Salmon, eds., *Les Lalanne* (Paris: Musée des Arts Décoratifs, 2010), 17–34.

105 Philippe Piguet, "Les Lalanne: la sculpture domestiquée," *L'Oeil*, no. 624 (May 2010): 50.

106 Gabet, "Les nouvelles Bucoliques," 33.

107 Bernard Frank, quoted in Sophie Delassein, "Les inclassables Claude et François-Xavier Lalanne," *L'Oeil*, no. 476 (November 1995): 60.

108 For example, see Peter Marino, *The Garden of Peter Marino* (New York: Rizzoli, 2017), in which sculptures by the Lalannes appear as accents throughout the grounds.

109 For example, the special exhibition *Les Lalanne at Fairchild*, organized by the Paul Kasmin Gallery and held at Fairchild Tropical Botanic Garden, Coral Gables, Florida, November 30, 2010–April 1, 2011. A group of *Moutons* by François-Xavier is also a popular and permanent fixture of the Missouri Botanical Garden in St. Louis.

110 François-Xavier Lalanne, quoted in Eric Jensen, "L'oeuvre poétique de Claude et François-Xavier Lalanne," *Point de Vue*, February 25, 1998, 40.

> *"We wanted to desacralize the work of art, to take it down from its pedestal. "*
>
> FRANÇOIS-XAVIER LALANNE, 1998[110]

CATALOGUE

KATHLEEN M. MORRIS

Objects are organized chronologically, by first appearance of the design or model. Both artists returned to some subjects over their careers, but the later versions of early objects often include significant variations. The first date listed after the object title is the date of the original design, and if the object on view in the exhibition was made later, the specific date of fabrication follows. Unless edition information is provided, the work is unique.

1.

CLAUDE LALANNE

Le Cabinet papillons (The butterfly cabinet), c. 1964
Cabinet: copper; jewelry: bronze, brass, gilded silver, gold
11 × 12 ½ × 5 ¹³/₁₆ in. (doors open)
(28 × 31.8 × 14.8 cm)
Private collection

This unique and exquisite object is one of the first independent works Claude made. She recalled working on it around 1964, welding sections of sheet copper together and creating a richly colored patina by means of a blowtorch. The assembled butterfly jewelry inside—necklaces, bracelets, earrings, and rings—were made to be worn and then stored in plain sight. When this object was displayed at the Louisa Guinness Gallery in London in 2016, Claude said of it, "I'm greatly influenced by nature and to me, this piece is like an organic form." Of the process she explained, "It's a combination of spontaneous design, soldering, and blowtorching. I worked intuitively to create this cabinet, sourcing the copper sheets and placing them together just as I felt they should be. Even now, my hands are often scarred with burns from my blowtorch."[111] Jewelry fashioned from galvanized bits of nature would become one of Claude's hallmarks, adorning her friends and taking its place on the runways of couturiers Yves Saint Laurent and, later, Dior.

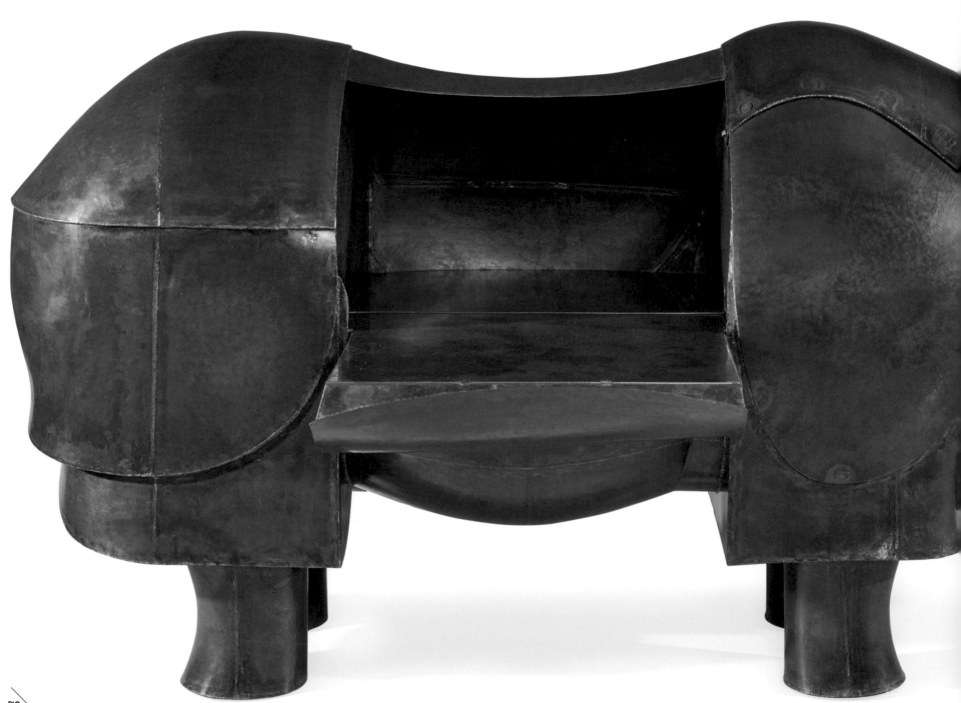

2.

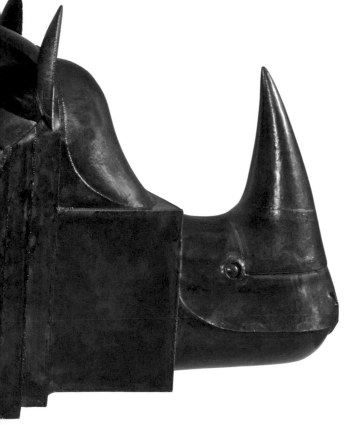

FRANÇOIS-XAVIER LALANNE
Grand Rhinocéros V (Large rhinoceros V), 1988/1991
Patinated welded copper
49 ⅝ × 100 ⅜ × 28 ⅜ in. (closed)
(126 × 262.6 × 72.1 cm)
Private collection

François-Xavier's first rhinoceros sculpture delighted the public and critics alike when shown at an exhibition at Galerie J in Paris in 1964. He made a total of five large-scale metal rhinoceroses and several small-scale versions over his career. His fourth large-scale example, which he called *Grand Rhinocéros V*, was designed in 1988 and fabricated in 1991. For this work, which is more streamlined than previous versions, François-Xavier abstracted elements of the animal using geometric forms such as cubes and cylinders and created a rich, complex patina through careful hand-finishing of the surface using chemicals and a blowtorch. This sculpture, which was still at the artists' home in Ury when Claude passed away, was the star lot of the highly successful L'Univers Lalanne: Collection Claude & François-Xavier Lalanne auction at Sotheby's Paris in October 2019.

Between François-Xavier's first life-size rhinoceros and this one, he made two other metal versions and one in soft materials. In 1966–67, two years after the Galerie J exhibition, he showed the second metal rhinoceros (*Rhinocrétaire II*) in Paris, Chicago, and New York; this was sold to his friend and architect Émile Aillaud. In 1971, for Daedalus Concepts, François-Xavier created two copies of a leather-wrapped foam rhinoceros that deconstructed to reveal several chairs (*Rhinocéros*), and in 1974 he was commissioned by French President Valéry Giscard d'Estaing to make a third unique metal rhinoceros sculpture, but Giscard canceled the order in 1975 after fabrication was already underway.[112] The completed sculpture (*Grand Rhinocéros III*) was exhibited at the Centre National d'Art Contemporain, Paris, in 1975, and was sold in 1977 to François de Menil,[113] who had inherited his passion for collecting from his parents, Dominique and John de Menil.[114] François-Xavier's fifth and final large-scale metal rhinoceros dates to 2002 and exists in a cast bronze edition of eight examples (*Grand Rhinocrétaire II*).

3.

CLAUDE LALANNE
Choupatte (Cabbagefeet), 2017
Galvanized copper
4 ½ × 4 ⅞ × 4 in. (11.4 × 12.4 × 10.4 cm)
Private collection

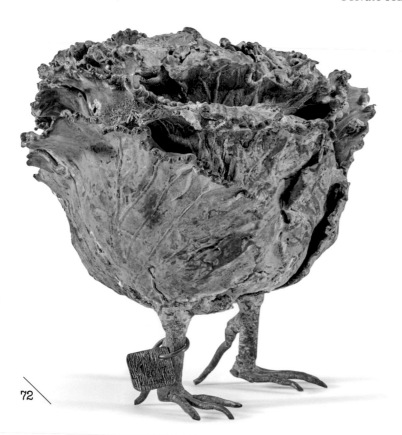

Claude showed her first two *Choupattes*, formed from galvanized natural components of cabbages and chicken feet, at the 1964 exhibition *Zoophites* at Galerie J in Paris. This surreal sculpture, which critic and writer John Ashbery likened to a creature from a painting by Hieronymus Bosch, signaled what would become an enduring interest for Claude: taking inspiration from ordinary objects found in the natural world and transforming them into new, strange, and compelling creations. To make these sculptures, Claude deconstructed real garden cabbages and galvanized each leaf—immersing them in an electrolytic bath and allowing copper to accumulate on their surfaces, then burning away any remaining organic material and welding the now-metallic leaves back together to recreate the familiar vegetal form. When making her first galvanized cabbage Claude noticed a pair of previously galvanized chicken feet in her studio and was inspired to add them to the sculpture, thereby creating what she called *Choupatte* (a combination of the French words for cabbage and animal feet). Throughout her career, Claude made the *Choupatte* in a variety of sizes, from very small (such as this example) to very large. Here she abstracted the feet rather than galvanize real chicken feet and added a small band around one leg like the identification tags used by farmers to mark their flocks. The *Choupattes* are among the most beloved of Claude's creations.

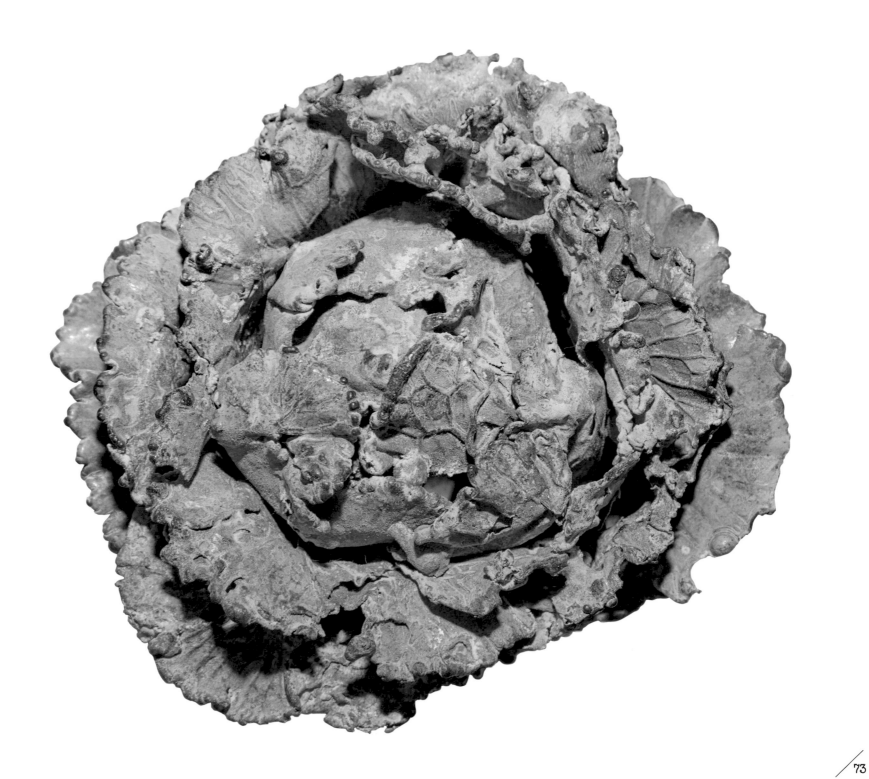

73

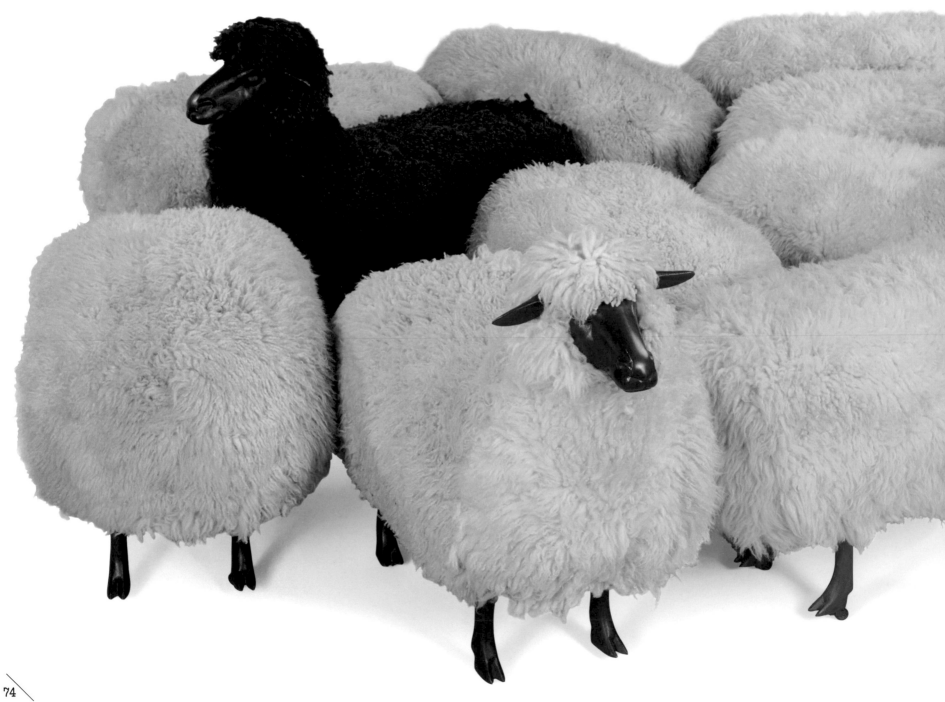

4.

FRANÇOIS-XAVIER LALANNE
Moutons de laine (Woolen sheep), 1968–71
1 black sheep, 1 white sheep, 5 ottomans: 1968
2 ottomans: 1969
1 white sheep: 1971
Patinated bronze, wool, aluminum, wood
Sheep: 35 × 36½ × 19 in. (88.9 × 92.7 × 48.3 cm) each
Ottomans: 21¼ × 31 × 18 in. (54 × 78.7 × 45.7 cm) each
Private collection

François-Xavier called his first group of twenty-four *Moutons* (made in 1965, some with sculpted heads and some without) *Pour Polyphème* (For Polyphemus), a reference to the mythological monster Polyphemus and his role in the epic story of Homer's *Odyssey*. Homer recounts how the one-eyed giant's flock of sheep became the escape mechanism for Odysseus and his men, who were trapped in Polyphemus's cave: they escaped by blinding the monster and then clinging to the bellies of the sheep as they were let out to pasture, while Polyphemus ran his hands over the sheep's empty backs. First shown at the annual group exhibition Salon de la Jeune Peinture in 1966, the *Moutons* were highlighted by critics Édouard Roditi and Otto Hahn as the best display in the show. While François-Xavier later created sheep in smaller groups, at first he insisted the entire flock of twenty-four remain together (see p. 23).[115] Together they formed a Surrealist sculpture, requiring an amount of floor space that undermined any rational purpose they could have served as chairs or footstools. This sense of humor is central to François-Xavier's animal-shaped "furniture." The *Moutons* have become among the best known and best loved of the Lalanne creations and François-Xavier made a number of versions over his career in both wool and cement, the latter for display outdoors.

The set of *Moutons* shown here include three sheep with sculpted heads and seven ottomans. François-Xavier handmade them between 1968 and 1971 for several different clients, and the current owner has assembled them into a new grouping. Several were once in the collection of American painter, writer, collector, publisher, and entrepreneur William N. Copley. The black *Mouton* was sent as a consolation gift to Copley by Adelaide de Menil on the occasion of his third divorce.[116]

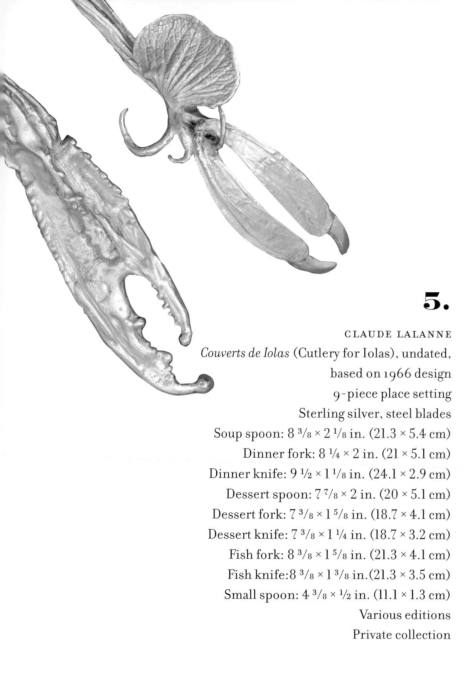

5.

CLAUDE LALANNE

Couverts de Iolas (Cutlery for Iolas), undated, based on 1966 design

9-piece place setting

Sterling silver, steel blades

Soup spoon: 8 ³/₈ × 2 ¹/₈ in. (21.3 × 5.4 cm)

Dinner fork: 8 ¹/₄ × 2 in. (21 × 5.1 cm)

Dinner knife: 9 ¹/₂ × 1 ¹/₈ in. (24.1 × 2.9 cm)

Dessert spoon: 7 ⁷/₈ × 2 in. (20 × 5.1 cm)

Dessert fork: 7 ³/₈ × 1 ⁵/₈ in. (18.7 × 4.1 cm)

Dessert knife: 7 ³/₈ × 1 ¹/₄ in. (18.7 × 3.2 cm)

Fish fork: 8 ³/₈ × 1 ⁵/₈ in. (21.3 × 4.1 cm)

Fish knife: 8 ³/₈ × 1 ³/₈ in. (21.3 × 3.5 cm)

Small spoon: 4 ³/₈ × ¹/₂ in. (11.1 × 1.3 cm)

Various editions

Private collection

As a result of their successful 1964 Galerie J show, *Zoophites*, in Paris, the Lalannes were taken up by gallerist Alexandre Iolas. He mounted an exhibition of their work at his Paris gallery in fall 1966, which was subsequently shown at the Art Institute of Chicago and the Alexander Iolas Gallery in New York in 1967, accompanied by a catalogue. Claude showed several works in this exhibition, most prominently a large set of silver flatware named for Iolas, comprising twelve place settings of nine pieces each, plus serving utensils. Created from a phantasmagorical combination of galvanized fragments of flowers, plants, insects, and crustaceans, this is no ordinary set of tableware. The audacious inventiveness of the construction—where form slyly winks at function—caught the attention of the press. Jean Cau mused about this service seen amid other works in the Lalannes' Paris apartment: "Fish knives—the blades are electroplated flower petals. Forks are decorated with dragonfly wings and the handles are shaped like birds' claws. The world's off its track; it slips through my fingers, eludes my reason, habits, all my lazy ways."[117] In 1966 Claude made pieces in both vermeil (gilded silver) and plain silver. Claude returned to this design for later sets,[118] as well as other patterns of tableware such as the *Phagocytes* of 1991, made for Artcurial.

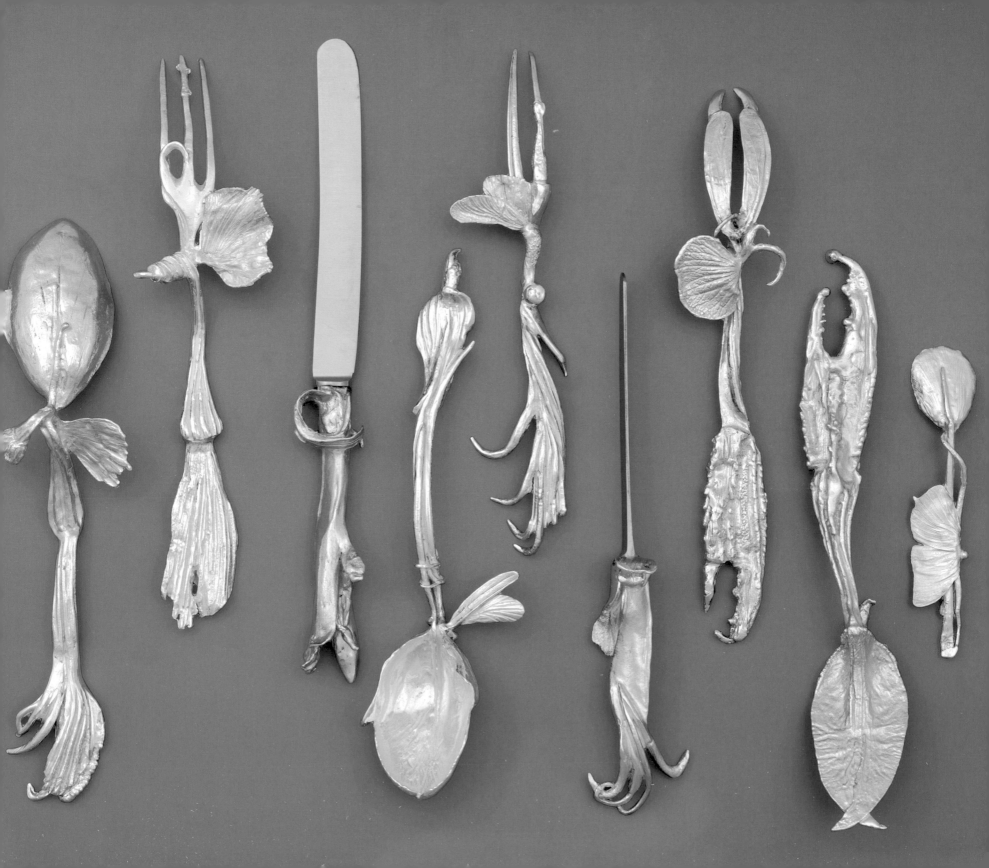

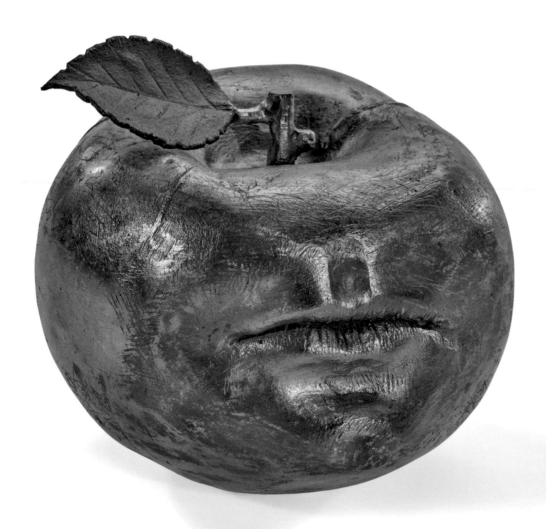

6.

CLAUDE LALANNE
Pomme Bouche d'Alan (Alan's apple mouth), 2009/2010
Bronze, galvanized copper
4 ¼ × 4 ⅜ × 4 ¾ in. (10.8 × 11.1 × 12.1 cm)
Edition of 100, #36/100
Laura and Stafford Broumand Collection

In 1968 Claude made her first *Pomme Bouche*, a combination of life-modeled human lips grafted onto an apple.[119] For this version, Claude started by making a wax model of a real apple, into which she worked a wax mold of human lips (the lips in the exhibited version belonged to a friend, Alan Watson, who worked at the Musée du Louvre). She then cast the model in bronze and completed it with galvanized apple leaves and a stem. The concept of animating an apple with human features exemplifies the artist's lifelong interest in melding the animal and vegetable worlds. The hybrid evokes connotations of the fall of man in the Garden of Eden, the touted health benefits of eating apples, the active role of the lips and mouth when eating an apple, and the mystery of an enigmatic expression, making the small sculpture a powerful holder of meaning.

As with other sculptures, Claude returned to this design a few years after creating the original to make additional versions for broader sale. Usually the editions made by both Claude and François-Xavier consisted of six or eight examples plus four artist proofs (all carefully overseen and finished by the artists), but the *Pomme Bouche* is one of the works that appeared in larger editions, this one an edition of one hundred (still overseen by Claude). This reflects the *Pomme Bouche*'s popularity over her career. After she first showed the sculpture at Alexandre Iolas's gallery in Milan in 1970,[120] Claude made an edition of 250 for Artcurial in 1975.[121] She made variations as well, including a 1970 *Pomme à Deux Bouches* (Apple with two mouths), that looks like an ordinary apple but opens to reveal two pairs of lips inside.[122]

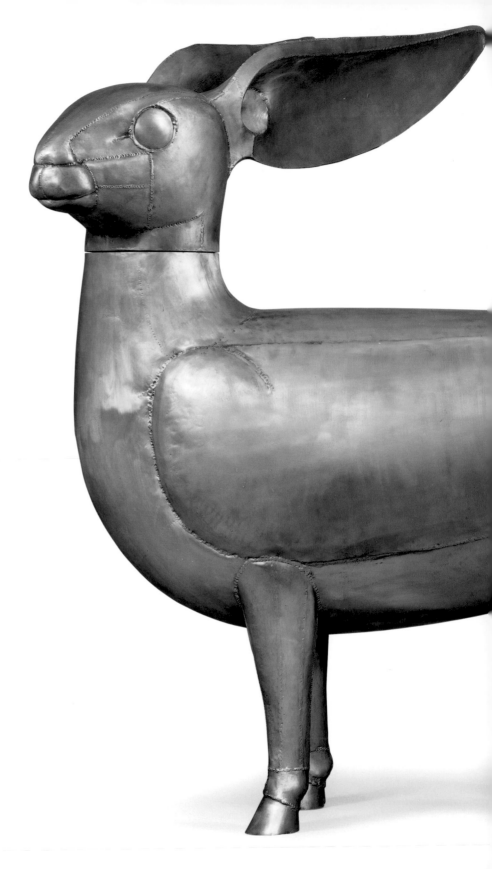

7.

FRANÇOIS-XAVIER LALANNE
Lapin à vent (Wind rabbit), 1994/2004
Gilt patinated bronze, ball bearings
70⅞ × 100⅜ × 18½ in. (180 × 255 × 47 cm)
Edition of 8 plus 4 artist proofs, #7/8
Private collection

In 1969 François-Xavier created a large brass sculpture
called *Lapin polymorphe* (Polymorphic rabbit) featuring
the head of a long-eared rabbit atop a body with bird wings
and a fish tail standing on four hoofed animal legs. The
same year he made another version with the head mounted
on ball bearings so that it could turn by pressure of the
wind. François-Xavier returned to the form several times,
including an edition started in 1994 that includes this
magnificent gilt bronze example made in 2004. It is one of
several polymorphic sculptures he created over his career,
combining parts of different animals in the tradition of

Ovid's *Metamorphoses* or children's fairy tales (see also fig. 30).

François-Xavier's first weathervane rabbit was made for the garden of the Fondation des Treilles in Tourtour, France, an intellectual and artistic retreat founded and developed by Anne Gruner Schlumberger.[123] Les Treilles lent the weathervane to the 1991 Lalanne exhibition at the Château de Chenonceau in the Loire Valley. François-Xavier also made the winsome hybrid creature as a small, tabletop-size sculpture.

8.

FRANÇOIS-XAVIER LALANNE
La Sauterelle (The grasshopper), 1970
Porcelain, polished brass, steel
25 ⅞ × 68 ¾ × 33 ½ in. (closed) (65.7 × 174.6 × 85.1 cm)
Edition of 2, unnumbered
Ben Brown Fine Arts, London and Hong Kong

Among the most iconic of François-Xavier's creations are his animal bars, starting with the rhinoceros bar shown at the Galerie J exhibition in Paris in 1964. Meticulously planned and executed, these works demonstrate his exacting technical skills as well as his love of whimsy and surprise. *La Sauterelle* at first appears as a sleekly stylized, giant sculpture of a grasshopper, but opens to reveal storage areas that perfectly fit wine and champagne bottles (see p. 66). These compartments evoke the idea of a grasshopper industriously storing up provisions for the winter (perhaps having learned his lesson from Aesop's fable "The Ant and the Grasshopper"), wryly suggesting that a good store of wine—or bubbly—is essential to survival. Additionally, the insect's brass wings pivot away from its body, ostensibly forming two narrow tabletops for glasses, though in reality they are too curved for practical use.

Made in an edition of only two (with porcelain components fired at the storied Sèvres manufactory), the fantastically enlarged insect is the type of object Claude referred to when she said of her husband, "He dreams wide awake and invites us to do the same."[124] The other edition of *La Sauterelle* was donated by French President Georges Pompidou to the Duke of Edinburgh in 1972, a marker of Les Lalanne's important role as artists creating work so unique and innovative that it could represent France as a diplomatic gift.

9.

CLAUDE LALANNE
Crocodile II, 1987/2005
Patinated bronze, galvanized copper, crocodile-skin
upholstered cushion
34 × 32 ½ × 25 in. (86.4 × 82.6 × 63.5 cm)
Edition of 8 plus 4 artist proofs, #6/8 B
Private collection

In 1972 Claude was given a small stuffed crocodile by a staff member of the Jardin des Plantes in Paris, leading to an explosion of creativity that resulted in a series of furniture items inhabited by galvanized crocodiles or their skins.[125] The semi-sinister surprise of finding a crocodile grappling along the back of an armchair that is further embellished with crocodile feet brings nature and humor into the potentially mundane realm of domestic furniture. Claude made the first crocodile armchair in 1972, and it was exhibited at the Maison de la Culture in Amiens, France, in 1973.[126] In addition to creating various tables and settees featuring crocodiles or their skins, she returned to the armchair form for several later versions, including this example from an 1987 design, which was made as one of a pair (one stamped "A," on which the crocodile's tail points down, the other "B," on which the tail points up). The pair was first shown in 1988 at the Marisa del Re Gallery in New York.[127] In addition to the stuffed crocodile that inspired all these creations, Claude bought a larger taxidermic crocodile that hung as a decoration on an exterior wall in the artists' home in Ury; however, she never used that version of the animal as a model for furniture, as the scale proved too large.

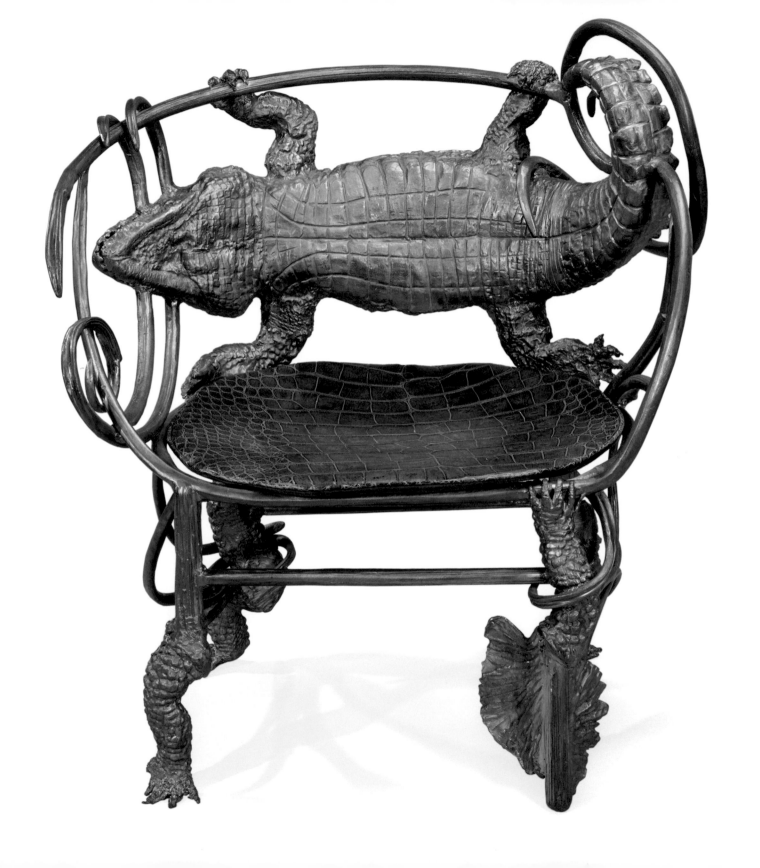

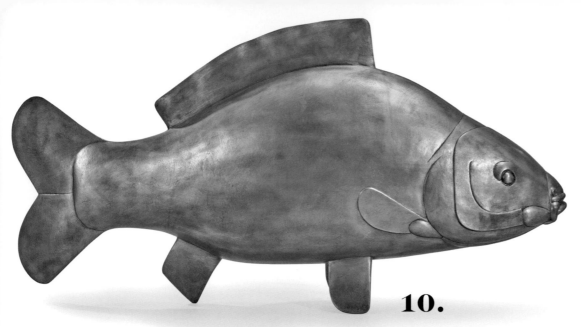

10.

FRANÇOIS-XAVIER LALANNE
Grande Carpe (Large carp), 1996/2001
Bronze
29 15/16 × 56 5/16 × 12 5/8 in. (76 × 143 × 32 cm)
Edition of 8 plus 4 artist proofs, #7/8
Private collection

11.

FRANÇOIS-XAVIER LALANNE
Très grande Carpe (Very large carp), 2000
Gilt bronze
52 × 98 ¾ × 23 in. (132.1 × 250.8 × 58.4 cm)
Edition of 8, #1/8
Private collection

In 1972 François-Xavier sculpted a large carp whose sides fold down to create a kind of table or double-sided writing desk.[128] The simplified form of the fish, whose eyes stare blankly in typical fish fashion, emphasizes the volume and structure of the sturdy creature, while the scale of the object and its transformation into a type of desk adds whimsy and surprise. François-Xavier returned to the carp to create sculptures in a range of sizes, though he eliminated the drop-down shelves in subsequent iterations, such as these two examples. Small gilt versions might find their places in an interior, while large and very large versions have been featured in many garden settings, often atop ponds or pools of water. Humorously hovering just above their natural habitat, these fish overturn our expectations of the norm. Recognizing the innate appeal of his chosen subjects, François-Xavier remarked on the Lalannes' work shown at the Bagatelle Gardens in Paris's Bois du Boulogne in 1998: "Because they are mostly animals, they seem to speak directly to children and to adults as a universal experience."[129]

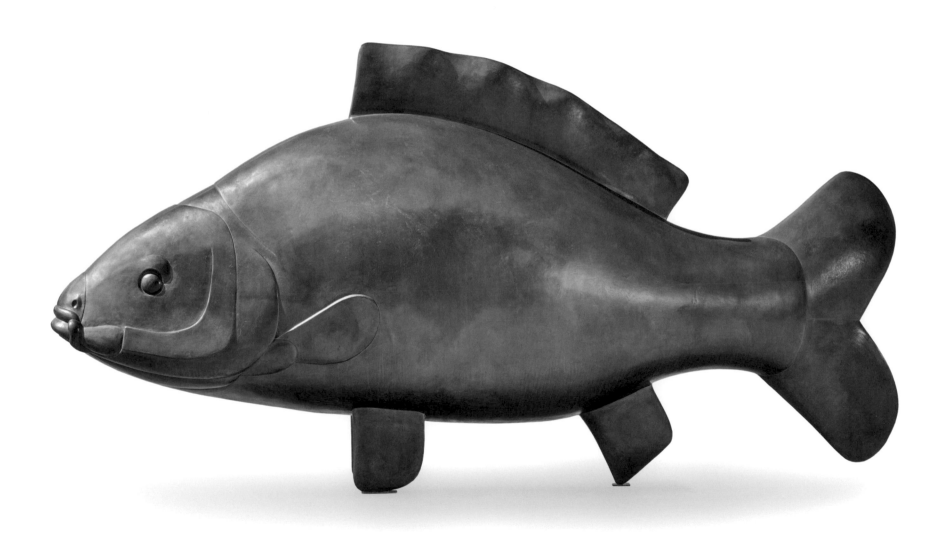

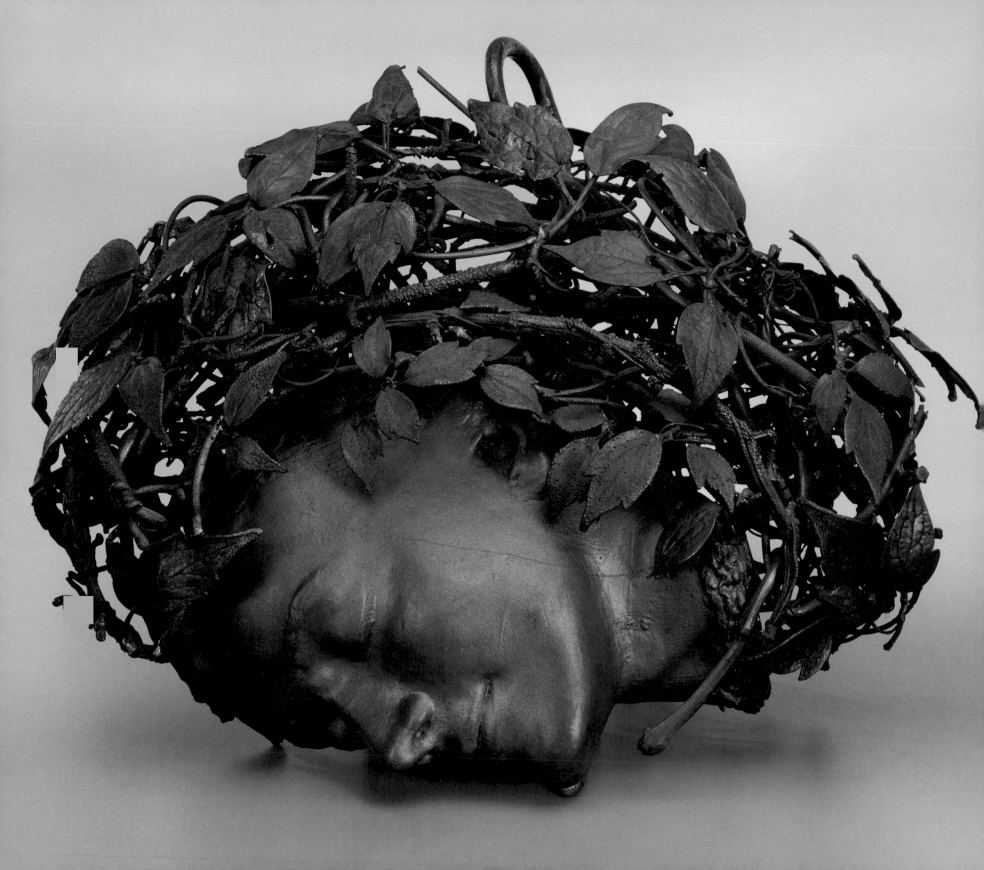

12.

CLAUDE LALANNE
La Dormeuse (The sleeping woman), 2004
Bronze, galvanized copper
11 13/16 × 15 3/8 × 11 13/16 in. (30 × 39 × 30 cm)
Private collection

Claude began working in the late 1960s with elastomer, a rubberlike substance, to create casts of the human body, which she used to make many works featuring likenesses taken from the faces and bodies of family and friends. The lovely visage of *La Dormeuse* began as an elastomer impression of the face of Claude's daughter Caroline, from which she created a wax model that was first galvanized, then cast in bronze, and finally coated with a thin layer of galvanized copper. The quality of the mold perfectly captures the soft texture of her daughter's skin, while Claude left in place thin metallic seams resulting from the fabrication process. She topped the head with a tumble of galvanized leafy vines rather than hair, punctuating the vines with solder accents. Through original techniques she had perfected over time, Claude achieved colorful patinas ranging from brown to copper to scarlet, suggesting a peaceful sleeper nestled in an autumnal landscape. Claude's first version of *La Dormeuse* was shown at Galerie Alexandre Iolas, Paris, in spring 1974.[130] A later version was featured on the cover of the November 1995 art magazine *L'Oeil* (see fig. 20A) as part of the magazine's coverage of the exhibition *Claude et François-Xavier Lalanne* at Galerie JGM in Paris. Intimate and personal in nature, *La Dormeuse* exists in only a few unique examples made over Claude's career.

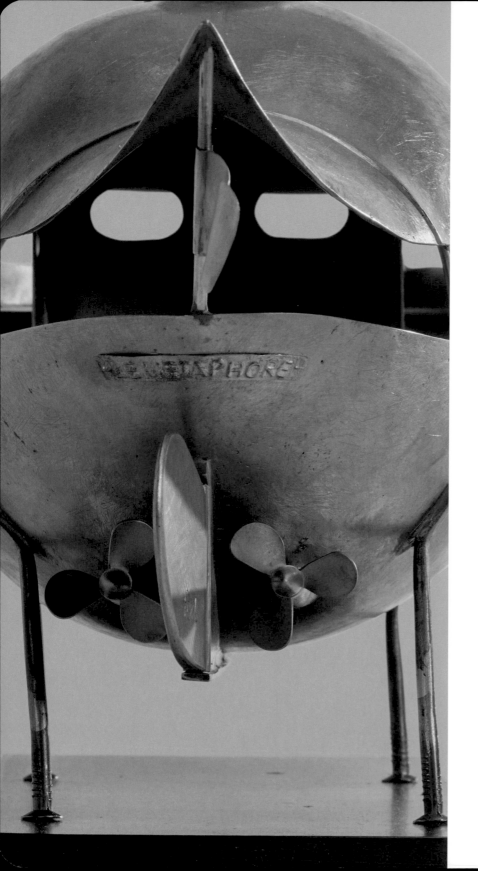

13.

FRANÇOIS-XAVIER LALANNE
Le Métaphore (Canard bateau) (The metaphor [duck boat]),
2002
Copper-manganese alloy
12 × 21 × 6 ½ in. (30.5 × 53.3 × 16.5 cm)
Edition of 8 plus 4 artist proofs, AP #6/8
Private collection

The inexhaustible imagination of François-Xavier
sometimes led him to creations that were to remain in the
realm of inspiration. In a 1975 drawing he conceived of
a large boat shaped like a duck with a capacious deck for
passengers beneath the bird's wings and a lookout deck for
the crew at the level of its neck (see fig. 23). He turned his
drawing into a small-scale model that same year; this version
is from 2002. Of François-Xavier's appropriation of animals
for human functions, this is perhaps one of the most logical—
ducks do swim in water, after all, and their feathers provide
a natural waterproofing, so the idea of a duck transformed

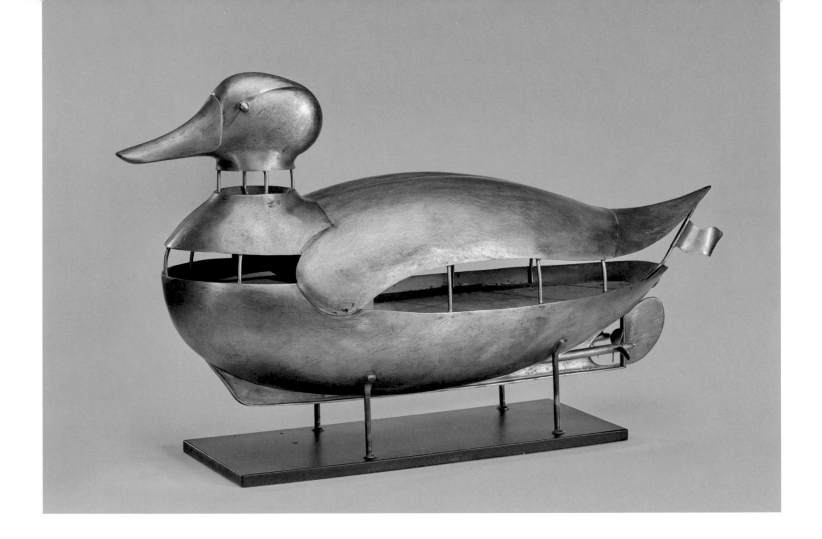

into a boat makes more sense than a rhinoceros-desk or a grasshopper-bar. The title suggests we should consider the object metaphorically, perhaps contemplating how modern conveyances such as boats and airplanes mimic, on a basic level, the characteristics of flotation and flying found in various birds. While the word "métaphore" in French is a feminine noun, François-Xavier has used the masculine article, possibly because "bateau" is masculine. Such tiny tricks with language reinforce the hybrid nature of his creations. The duck boat also conveys the Lalannes' sense of humor. In thinking about the transformations both Claude

and François-Xavier created, Robert Rosenblum noted, "While some of their metamorphic miracles may make us think of a fable of Ovid, in which a human being, like Daphne, can turn into a tree; others are more at home in the domain of childhood fantasy. . . where a duck can become a magic boat to transport us to faraway places."[131]

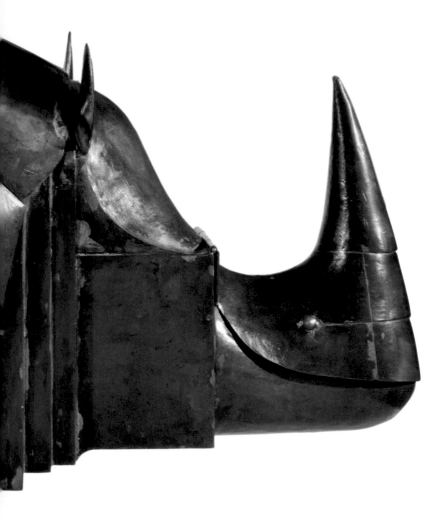

14.

FRANÇOIS-XAVIER LALANNE
Petit Rhinocéros mécanique (Small mechanical rhinoceros),
1976/1983
Copper
9¹³⁄₁₆ × 21⅝ × 5 ½ in. (25 × 55 × 14 cm)
Edition of 6 plus 2 artist proofs plus 2 hors commerce, #5/6
Galerie Lefebvre, Paris

In addition to the six large-scale rhinoceros sculptures that François-Xavier created over his career (see cat. 2), he also made a number in smaller scale. Beginning in 1976 he made an edition of small rhinoceros sculptures featuring multiple hinged doors, which he called *Petit Rhinocéros mécanique*. The example seen here is dated 1983 on one of the compartment doors.[132] These rare "mechanical" sculptures were handmade with extreme precision, with each compartment opening and closing flawlessly. One of the mechanical versions, made in 1978, was designed at the client's request to hold a set of eleven blown-glass condiment jars.[133] From around 1974 onward, François-Xavier also made editions of small, non-opening rhinoceros sculptures (*Petit Rhinocéros III* and *IV*) in copper, patinated bronze, gilded bronze, cast iron with blue enamel finish (plus unenameled examples), and a unique polished black marble example.

In 1980 François-Xavier made a colored etching titled *La mémoire du rhinocéros* (The memory of the rhinoceros) (see fig. 18) and mounted the exhibition *Le Rhinocéros dans tous ses ètats* (The rhinoceros from every angle) at the Galerie La Hune in Paris. Throughout his long career, the rhinoceros remained one of François-Xavier's favorite motifs.

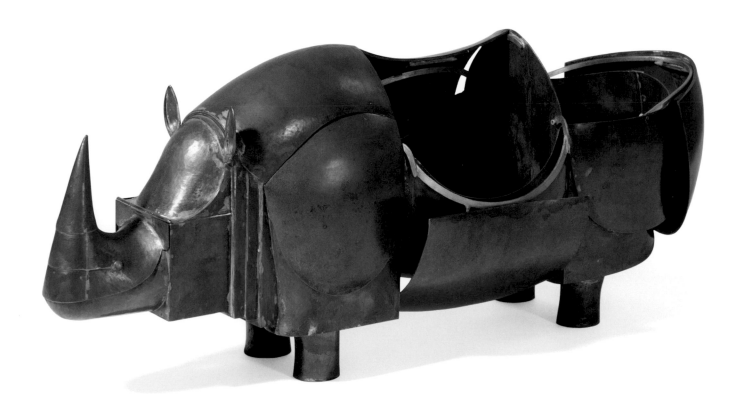

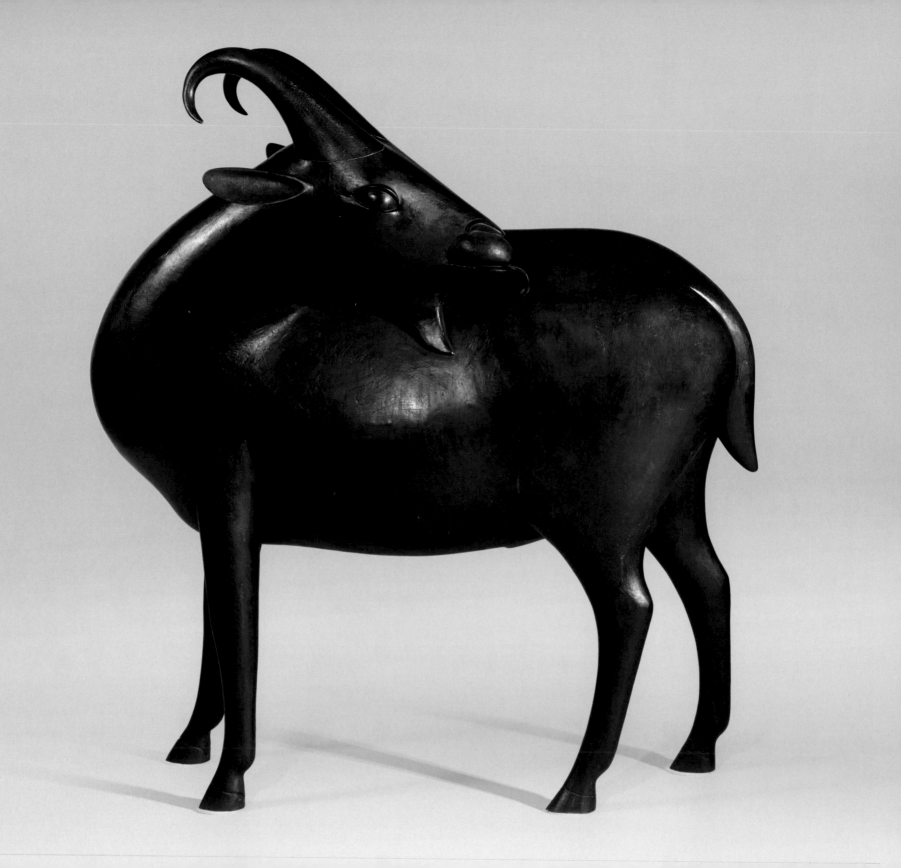

15.

FRANÇOIS-XAVIER LALANNE
Mouflon de Pauline (Pauline's mouflon), 1993/2007
Patinated bronze, leather, wood, brass, with red-painted
interior
50 ½ × 49 ¼ × 19 ⅛ in. (128.3 × 125.1 × 48.6 cm)
Edition of 8 plus 4 artist proofs, #8/8
Private collection

The *Mouflon de Pauline*, first made in 1993 for the artists'
friend and collector Pauline Karpidas, is a beautiful example
of the kind of transformational animal sculpture François-
Xavier is known for. A sleekly stylized mouflon, a type of
wild sheep, appears to be pure sculpture, designed and
fabricated with the artist's usual rigor and precision, but
a nearly hidden door opens to reveal a writing surface and
interior desk (other versions of the desk have differently
styled doors). In 1990 François-Xavier said, "Animals have
always fascinated me, perhaps because they are the only
beings through which we can enter into contact with another
world."[134] Here the sculpted animal disregards us, turning its
head backward to lick its fur. We may enter into the animal in
a literal sense—by opening it and storing books or stationery
within—but we may be even more tempted to gain access
into the mind of the serene, self-involved creature. At once
accessible and remote, the sculpture brings the mysterious
world of nature into human spaces.

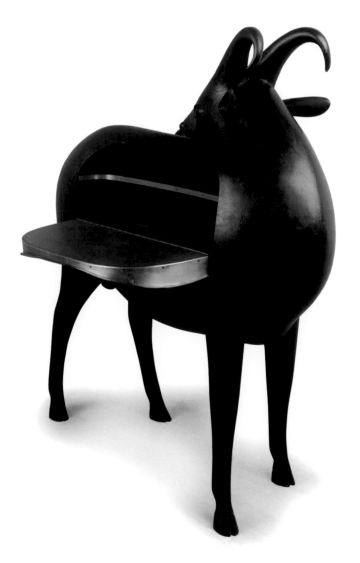

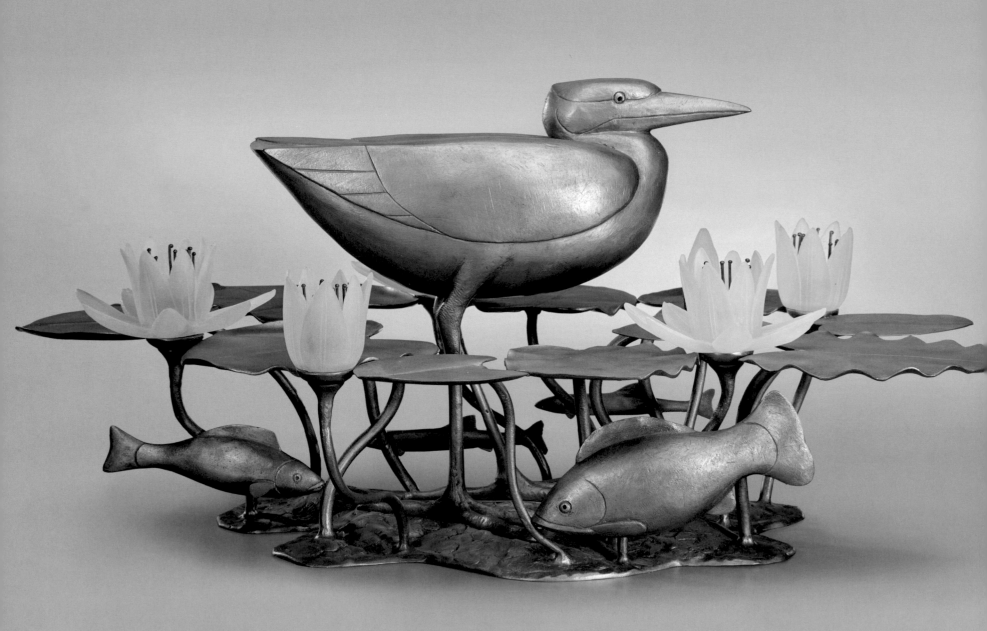

16.

FRANÇOIS-XAVIER LALANNE
Histoires naturelles, Héron
(Natural histories, heron), 2006/2010
Bronze, glass
13 × 29 15/16 × 18 7/8 in. (33 × 76 × 48 cm)
Edition of 8 plus 4 artist proofs, #3/8
Private collection

In this tabletop sculpture, one of a group created by François-Xavier in 2006, the heron's long legs bring his body well above the level of the water lilies, while small and medium-size fish swim unnoticed (for the moment) among the plant's stems and the bird's legs. Part of a series called *Histoires Naturelles*, other items in the group included large pieces fitted with candleholders, as well as smaller sculptures and standing vases formed of abstracted ducks, herons, sandpipers, moorhens, seaweed, water reeds, and fish. The components could be used individually or combined to create an elaborate table decoration. The entire series was shown at JGM Galerie in Paris in 2013, and the accompanying catalogue featured a poetic musing on the series written by François-Xavier's daughter, Dorothée Lalanne:

> On the surface of the water,
> the traffic is light. . .
> But under the waves,
> other creatures cross paths
> with each other,
> sometimes feeding the former,
> like ideas floating above
> a perfect dinner party[135]

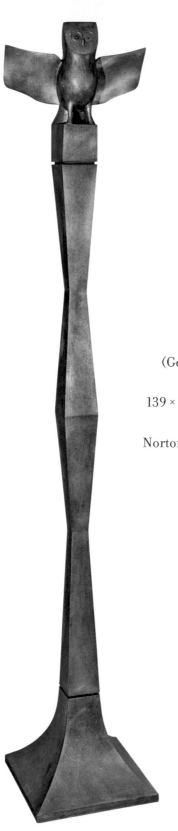

17.

FRANÇOIS-XAVIER LALANNE
Génie de Bellerive sur pylône
(Genius of Bellerive on pylon), 2007/2015
Bronze
139 × 23 ½ × 23 ½ in. (353.1 × 59.7 × 59.7 cm)
Edition of 8 plus 4 artist proofs, #5/8
Norton Museum of Art, gift of Jane B. Holzer,
in honor of her parents Helen and
Carl Brukenfeld, 2016.248

Late in his career, François-Xavier fashioned a sculpture in tribute to two artists who had been his friends earlier in life. He saw a version of Max Ernst's *Génie de la Bastille* (1960) in Princess Catherine Aga Khan's Bellerive gardens in Switzerland, and was inspired to make a companion sculpture for her.[136] The abstracted owl atop the pylon, wings outstretched, recalls the humanoid figure Max Ernst placed on a tall spindly column. While echoing the Ernst column, the pylon of the *Genie de Bellerive* has a more geometric form, akin to Constantin Brancusi's *Endless Column* (1918). During François-Xavier's early career, Brancusi's studio stood adjacent to his own and the older artist stopped by each day to share ideas and relax with him and Claude, while Ernst's studio was just down the hall. Brancusi died in 1957 and Ernst in 1976, making this late-in-life sculpture by François-Xavier a poignant remembrance of two great sculptors whose work he admired. François-Xavier may have intended a mischievous hidden meaning as well. Claude recalled that Brancusi did not like Ernst "because he was too tall. Brancusi used to say that Max was looking down on him, that he was sucking his vital energy."[137] In François-Xavier's homage, Ernst can be seen as standing on the shoulders of a giant, his own work dependent upon Brancusi's pioneering example; in a less metaphoric sense, François-Xavier has allowed Ernst to literally tower over Brancusi.

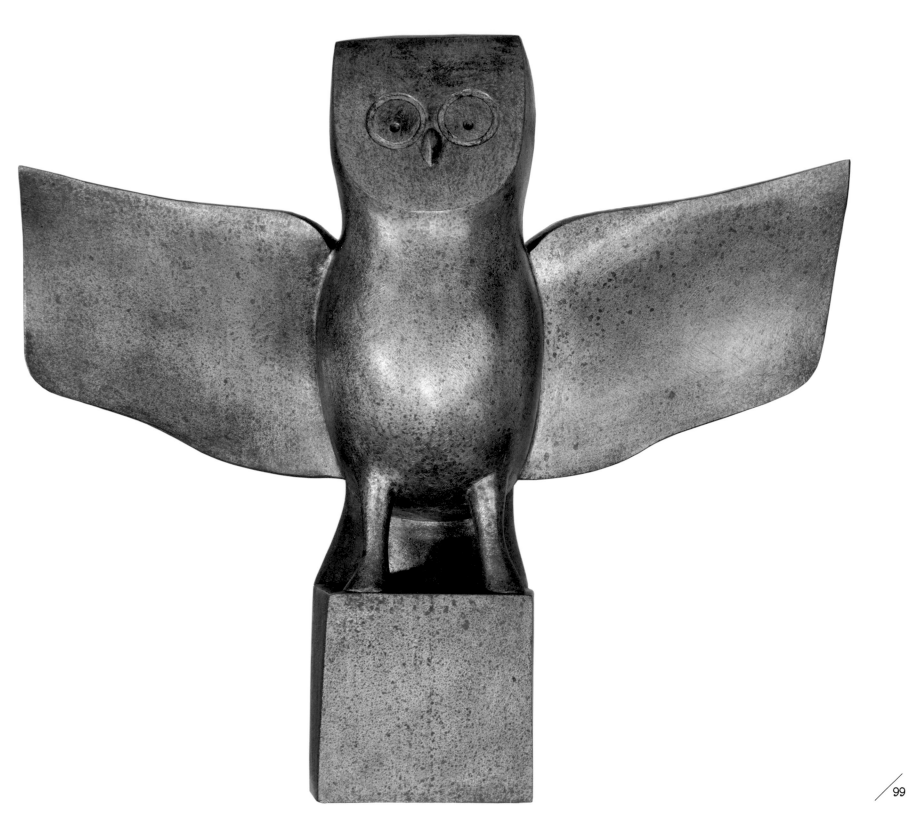

18.

CLAUDE LALANNE
Très grand Choupatte (Very large cabbagefeet), 2008/2012
Patinated bronze
46 × 53 ⅛ × 53 ⅛ in. (117 × 135 × 135 cm)
Edition of 8 plus 4 artist proofs, #7/8
Private collection

In a lithograph François-Xavier published in *Polymorphoses* in 1978, he populated a landscape with large versions of the *Choupatte*, along with this text:

> If a planet existed where plants moved on feet, one would see the grass run away at the approach of a cow. Unless in that world, the animals were rooted to the ground like an oyster to a rock. Therefore the fixed would take hold of the mobile. Like a carnivorous plant. The animal would thus become the vegetal. Perhaps in the end, we live on another planet.[138]

Thirty years later, Claude took François-Xavier's imagined giant *Choupatte* and turned it into reality. Claude enlarged the scale of the *Choupatte* far beyond the natural size of cabbages, first in 2008, with the "very large" version as in this example, and again in 2016 with a "giant" size, nearly six feet tall and six feet in diameter. For these supernatural vegetables, Claude individually modeled each of the enormous cabbage leaves in wax, had them cast in bronze, and then welded them together to form the typical arrangement of tightly compressed leaves. Working on the large scale of these sculptures opened new avenues for Claude's creativity and posed new technical challenges. The shift in scale also creates different connotations: the nearly human-size chicken-footed cabbage may seem almost menacing in its mindless animism, although some collectors have used it as a humorous (and presumably peaceable) accent in private gardens.

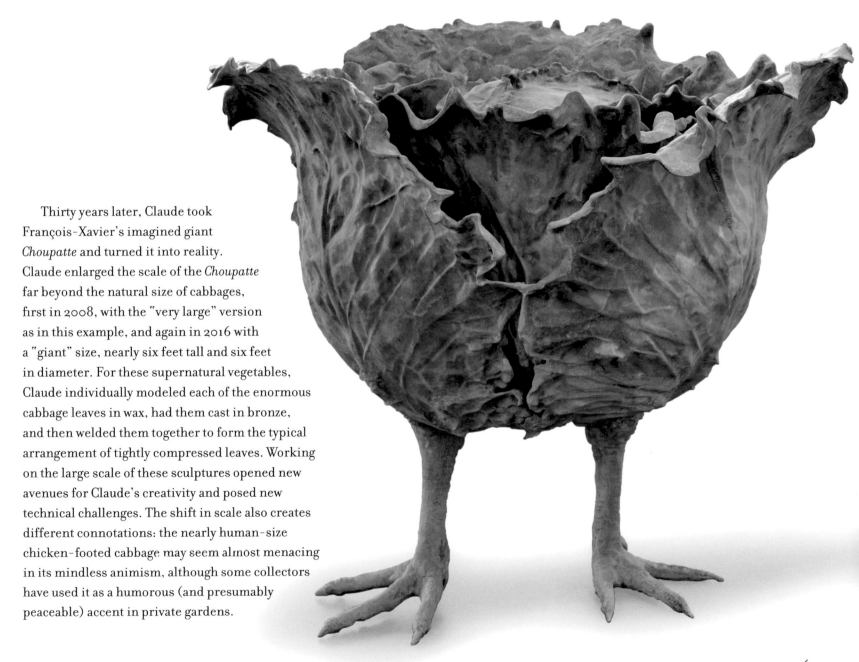

19.

CLAUDE LALANNE AND FRANÇOIS-XAVIER LALANNE
Singe aux Nénuphars (Monkey with lilies), 2007/2008
Bronze
19 ¾ × 12 ½ in. diameter (50 × 54 cm)
Edition of 8 plus 4 artist proofs, #7/8 A
Brian McCarthy and Daniel Sager

This small table, one of a pair stamped *A* (with the monkey looking right) and *B* (monkey looking left), is one of the rare collaborations between François-Xavier and Claude. It combines a seated monkey, designed by François-Xavier, with a round tabletop formed by water lily leaves, created by Claude. The animal clasps its toes and holds the tabletop above its head with both hands. The tabletop, designed with an opening between the leaves at front, allows us a clear view of the mischievous grin on the monkey's face. The piece's individual components had appeared in earlier works by each artist—François-Xavier modeled the monkey in plaster in 2002,[139] while Claude first made a table with a top formed of overlapping water lily leaves in 1999 (*Guéridon nénuphar*, on which the leaves appear in a different configuration). Claude often used leaves as decorative motifs, sometimes enlarging their size to transfer the beauty of their form to a bolder scale. Here, the lilies are life-size or near to it, as is the monkey, whose form François-Xavier simplified. Claude and François-Xavier first collaborated to make this table in 2007. The example shown here is from the original edition; it was subsequently released in small editions of gilt bronze and aluminum.

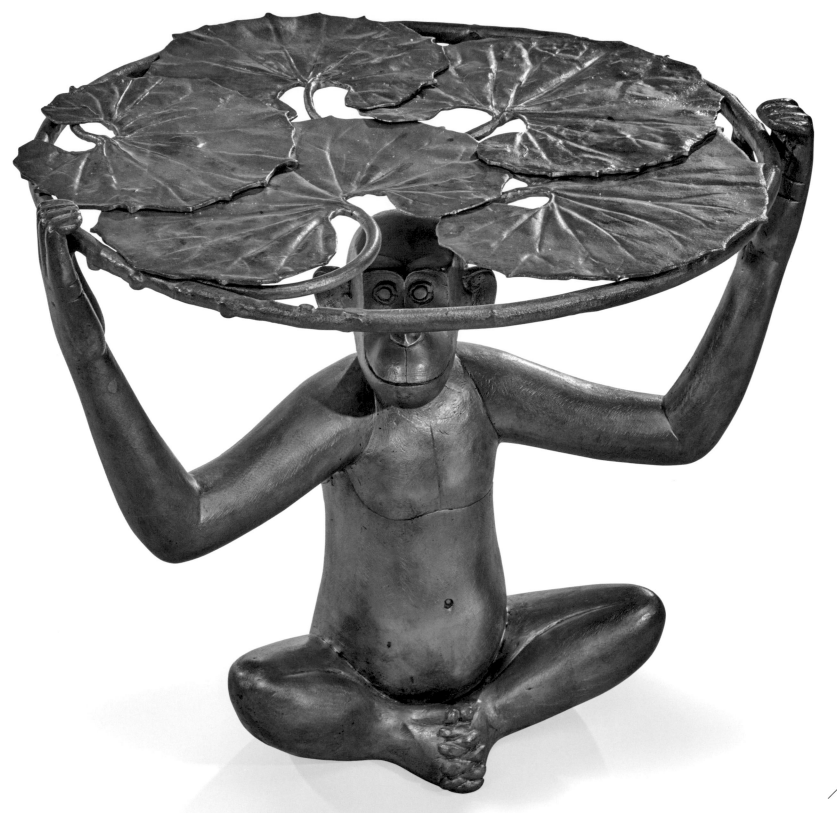

20.

CLAUDE LALANNE
Les Berces adossées (The hogweed back-to-back), 2015
Bronze
42⅛ × 96 × 29⅞ in. (107 × 244 × 76 cm)
Edition of 8 plus 4 artist proofs, #1/1 M (model,
version A)
Private collection

In the mid-1990s, Grega Daly—who along with her husband, architect Leo Daly, was a friend of the Lalannes—brought ginkgo tree leaves back from Japan as a gift for Claude.[140] In many Asian countries the ginkgo tree has long been seen as a symbol of longevity, possessing miraculous powers. Claude fell in love with the plant's elegant fan shape and turned those original leaves into jewelry that she gave to Mrs. Daly. Claude continued to make jewelry using the motif of life-size ginkgo leaves, and she also was inspired to enlarge the leaf for a series of chairs, tables, and benches.

In this large bench, designed and fabricated in 2015, eight gigantic ginkgo leaves create the seat and back support. Claude used *berce* stems (a plant known as *heracleum* in Latin, or hogweed in English) to model the bench's legs and crossbars, perhaps reflecting on the fact that hogweed has stems of remarkable strength. The combination of hogweed and ginkgo suggests strength and good fortune—a meaningful combination to support a person who is resting on a chair or working at a table. Here, in a full expression of their mystical form, the leaves of the Asian ginkgo entwine around the coarse stems of a common weed, their scale and placement suggestive of protection and safety.

21.

CLAUDE LALANNE
Banc s'asseoir en forêt (Bench sitting in forest), 2017
Bronze
32 $\frac{5}{16}$ × 61 × 34 $\frac{1}{4}$ in. (82 × 155 × 87 cm)
#1/1 M (model)
Private collection

In 2017 and 2018 Claude created two unique benches formed from tangles of cast, cut, and welded branches and vines. These works are technically complex and, as with all her works, the effect that Claude was seeking could only be achieved through trial and error. As the bench was in the process of construction she would decide the form was not right and elements already welded into place would need to be removed and replaced or repositioned; this process was repeated multiple times until she judged it to be complete (by this time in her life, this heavy work was by necessity done by studio assistants). The finished benches have a feeling of natural nests of fallen branches and vines one might come across on a walk in a dense forest. The beauty of the form belies the difficulty in constructing the work to achieve both the desired aesthetic and the strength and shape to function as a useable bench. This is among the last works Claude completed before her death in April 2019.

CATALOGUE NOTES

111 Claude Lalanne, quoted in Aimee Farrell, "The Making of Claude Lalanne's Exquisite Copper Jewelry Box," *New York Times Style Magazine*, June 8, 2016.

112 Information provided to author by the Lalanne studio archives, October 28, 2019.

113 Information provided to author by the Lalanne studio archives, October 28, 2019.

114 The 1964 rhinoceros is now in a private collection; the 1966 version is in the collection the Musée des Arts Décoratifs, Paris. The 1975 version was sold by de Menil at Sotheby's in 1985, where it was purchased by Frederick R. Weisman, who used it as his desk until his death. It now is part of the Frederick R. Weisman Art Foundation, Los Angeles, and remains in Weisman's office. The titles of the rhinoceros sculptures used in the catalogue were provided to the author by the Lalanne studio in January 2020.

115 A group of *Moutons* was featured in a fall 1966 Galerie Alexandre Iolas exhibition in Paris, which moved on to the Art Institute of Chicago and then the Alexander Iolas Gallery in New York in 1967 (see page 126). While on view in Chicago, the *Moutons* may have been sold to a local collector; a letter from Art Institute of Chicago curator A. James Speyer to the Galerie Alexandre Iolas in Paris of March 29, 1967, reported that a female collector well-known to the Art Institute was interested in buying around sixteen of them (twenty-two were included in the exhibition). While the response from the gallery is not recorded, an undated list of exhibited works in one of Speyer's files has the handwritten word "SOLD" next to the entry for the *Moutons* (A. James Speyer Records. AIC Archives 318-0010). In a review of the Alexander Iolas Gallery show in New York that opened within weeks of the show's close in Chicago, influential fashion writer Eugenia Sheppard reported that the entire flock had been sold to a single buyer. Thus an American collector was likely one of the earliest purchasers of the *Moutons*. Eugenia Sheppard, "Not Quite Furniture," *World Journal Tribune*, April 12, 1967, 17.

116 Marchesseau, *The Lalannes*, 36, and Hannah Martin, "Herd Mentality," *Architectural Digest*, February 2017, 28.

117 Cau, "Marvellous Trickery," 151.

118 One place setting of the *Couverts de Iolas* is in the collection of the Cooper Hewitt, Smithsonian Design Museum, New York (CH1990-137-1/9), and one place setting plus one serving piece are in the collection of the Musée des Arts Decoratifs, Paris (Inv.2016.71.2.1-10). An edition dated 2015 is illustrated in *Claude & François-Xavier Lalanne* (2016), 40–41.

119 The first *Pomme Bouche* was based on unidentified set of lips. Claude used elastomer to take the impression of the actual lips, and from that created a wax mold.

120 Rosenblum, *Les Lalanne*, 59.

121 See Dannatt, ed., *Les Lalanne,* 43, for a 1975 Artcurial advertisement in *L'Officiel des Spectacles* offering gilt-bronze examples from an edition of 250 for 3,500 ff each.

122 Illustrated in Forest and Salmon, eds., *Les Lalanne*, 125.

123 "Chronologie," *Claude & François-Xavier Lalanne*, 73. The extensive collection at Les Treilles includes works by a wide range of artists, with at least ten works each by François-Xavier, Max Ernst, Diego Giacometti, Pablo Picasso, and other prominent artists.

124 Claude Lalanne, quoted in *Claude & François-Xavier Lalanne* (2013), 24.

125 Reinforcing the crocodile theme, Claude made cushions for her chairs using legally and humanely sourced crocodile skins.

126 Rosenblum, *Les Lalanne*, 20.

127 Abadie, *Lalanne(s)*, 333. An example of the 1987 *Crocodile II,* version A is in the collection of the Moderna Museet in Stockholm, donated in 2005 by influential art collector and founding director of the Centre Pompidou, Paris, Pontus Hultén. While Hultén's relationship with the Lalannes was complicated due to his support of Jean Tinguely, with whom François-Xavier had a famous falling-out (see Abadie, *Lalanne(s)*, 210-11), the Pompidou acquired works by both artists during his directorship (1974 81) and mounted the first significant exhibition of their work in 1975.

128 This was first shown at the Galerie Alexandre Iolas in Paris in 1972. Abadie, *Lalanne(s)*, 310.

129 François-Xavier Lalanne, quoted in Abadie, *Lalanne(s)*, 342.

130 Abadie, Lalanne(s), 314. The first *Portrait de Caroline* (without the vines) was cast around 1970. Abadie, *Lalanne(s)*, 211.

131 Rosenblum, *Les Lalanne*, 134.

132 Additional examples from the mechanical edition were sold in the Jacques Grange: Collectionneur auction at Sotheby's Paris, November 21, 2017, lot 36 (dated 1988), and at the Univers Lalanne: Collection Claude & François-Xavier Lalanne auction, Sotheby's Paris, October 24, 2019, lot 101 (dated 1987).

133 Sold at Christie's Paris, May 28, 2010, lot 246.

134 "Les Lalanne: Les Silhouettes et les Phagocytes," 5.

135 *Claude & François-Xavier Lalanne* (2013), 40.

136 André Mourgues recalls being with Claude and François-Xavier during this visit and the conversation between Catherine Aga Khan and François-Xavier that inspired the *Génie de Bellerive sur pylône*; conversation with the author, February 22, 2021.

137 "Interview with Claude Lalanne," Alain Elkann Interviews.

138 English translation from *Claude & François-Xavier Lalanne* (2016), 17.

139 Abadie, *Lalanne(s)*, 30–31.

140 Dannatt, *François-Xavier and Claude Lalanne*, 219.

EXHIBITION IMAGES

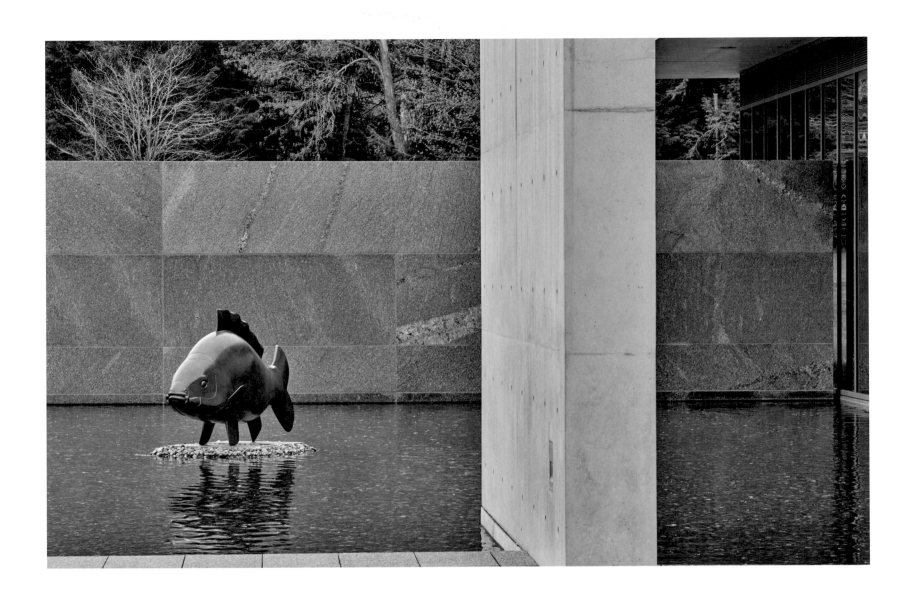

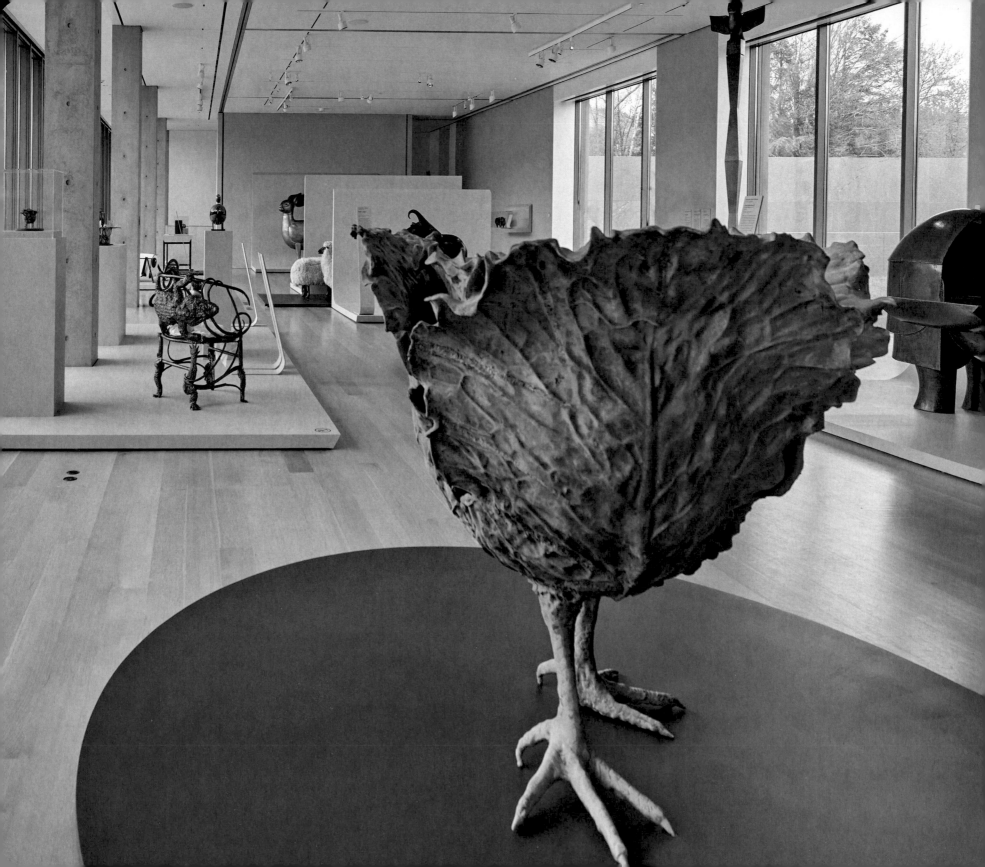

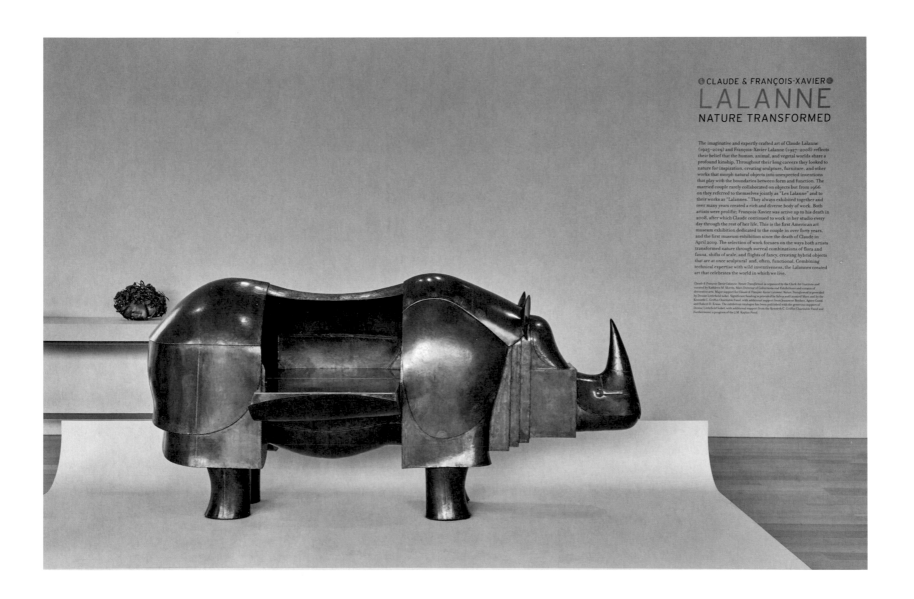

●CLAUDE & FRANÇOIS-XAVIER●
LALANNE
NATURE TRANSFORMED

The imaginative and expertly crafted art of Claude Lalanne
(1925–2019) and François-Xavier Lalanne (1927–2008) reflects
their belief that the human, animal, and vegetal worlds share a
profound kinship. Throughout their long careers they looked to
nature for inspiration, creating sculpture, furniture, and other
works that morph natural objects into unexpected inventions
that play with the boundaries between form and function. The
married couple rarely collaborated on objects but from 1966
on they referred to themselves jointly as "Les Lalanne" and to
their works as "Lalannes." They always exhibited together and
over many years created a rich and diverse body of work. Both
artists were prolific; François-Xavier was active up to his death in
2008, after which Claude continued to work in her studio every
day through the rest of her life. This is the first American art
museum exhibition dedicated to the couple in over forty years,
and the first museum exhibition since the death of Claude in
April 2019. The selection of work focuses on the ways both artists
transformed nature through surreal combinations of flora and
fauna, shifts of scale, and flights of fancy, creating hybrid objects
that are at once sculptural and, often, functional. Combining
technical expertise with wild inventiveness, the Lalannes created
art that celebrates the world in which we live.

Claude & François-Xavier Lalanne: Nature Transformed is organized by the Clark Art Institute and
curated by Kathleen M. Morris, Marx Director of Collections and Exhibitions and curator of
decorative arts. Major support for Claude & François-Xavier Lalanne: Nature Transformed is provided
by Denise Littlefield Sobel. Significant funding is provided by Sylvia and Leonard Marx and by the
Kenneth C. Griffin Charitable Fund, with additional support from Jeannene Booher, Agnes Gund,
and Robert D. Kraus. The exhibition catalogue has been published with the generous support of
Denise Littlefield Sobel, with additional support from the Kenneth C. Griffin Charitable Fund and
Furthermore: a program of the J. M. Kaplan Fund.

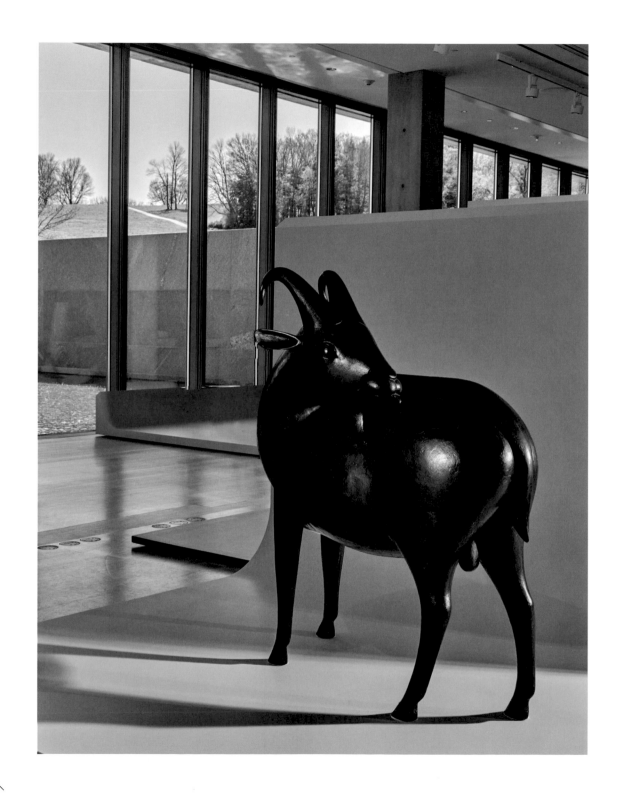

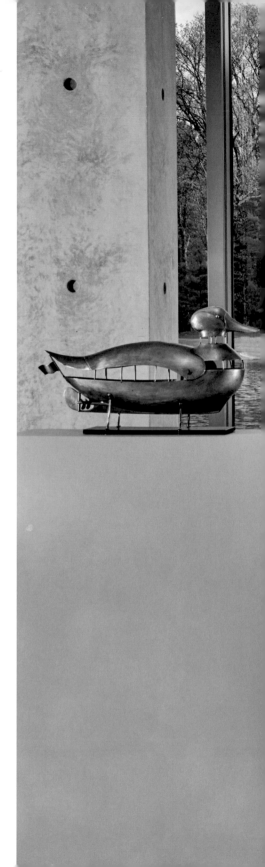

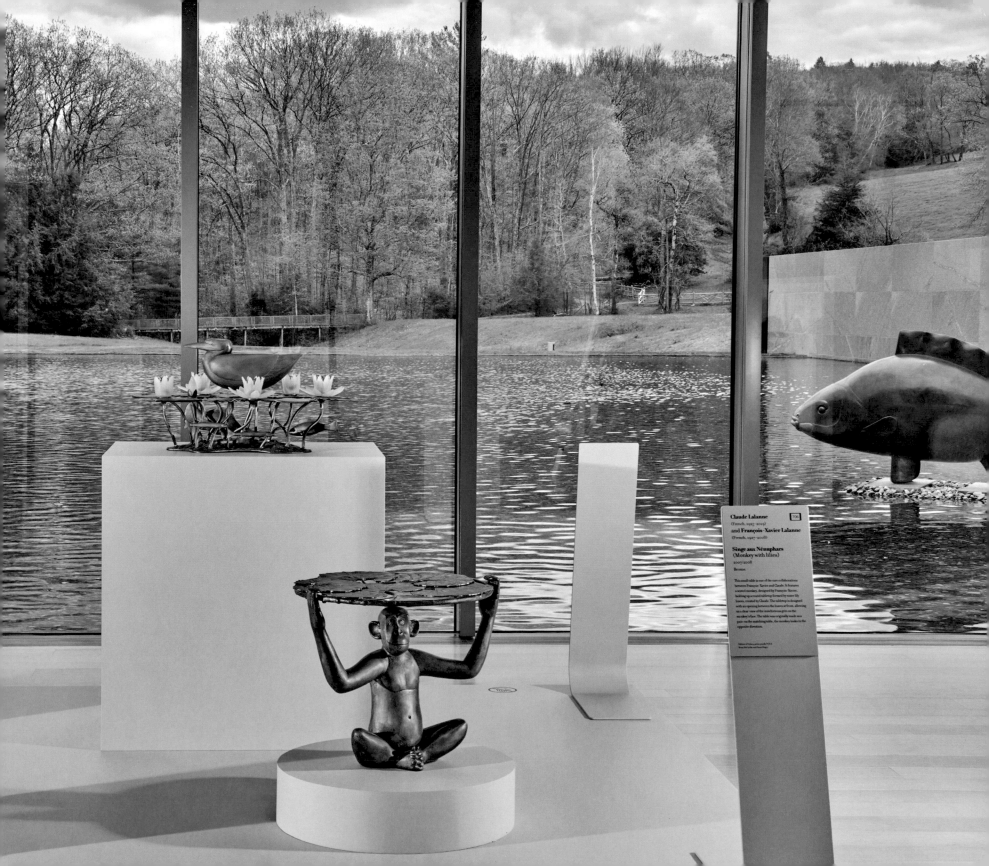

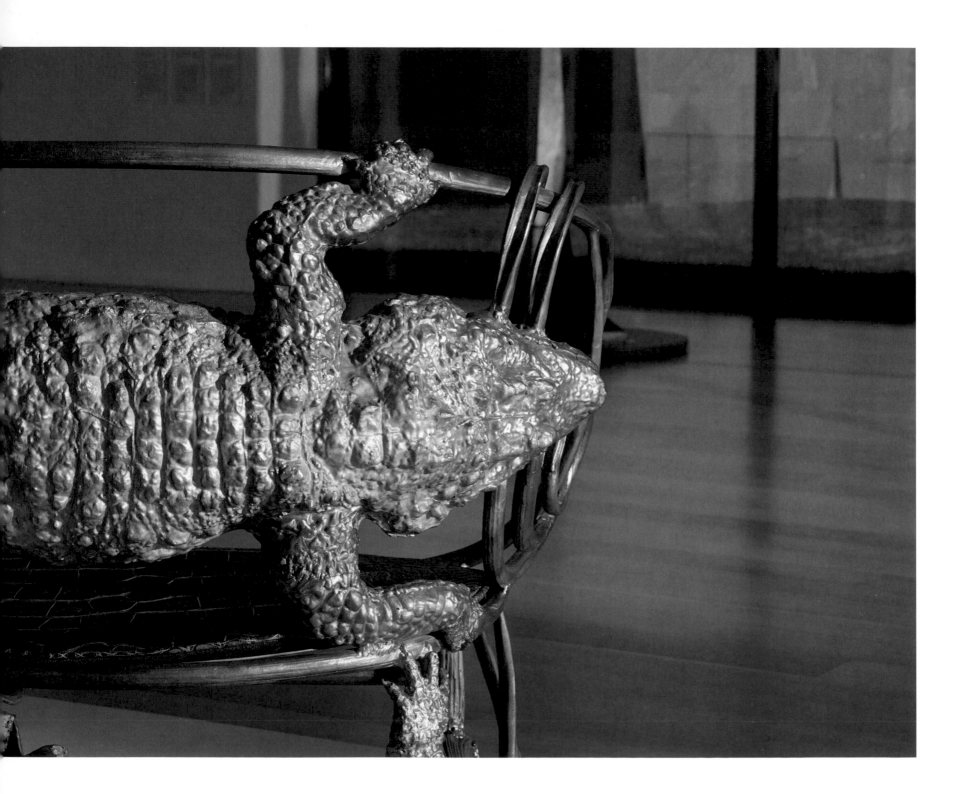

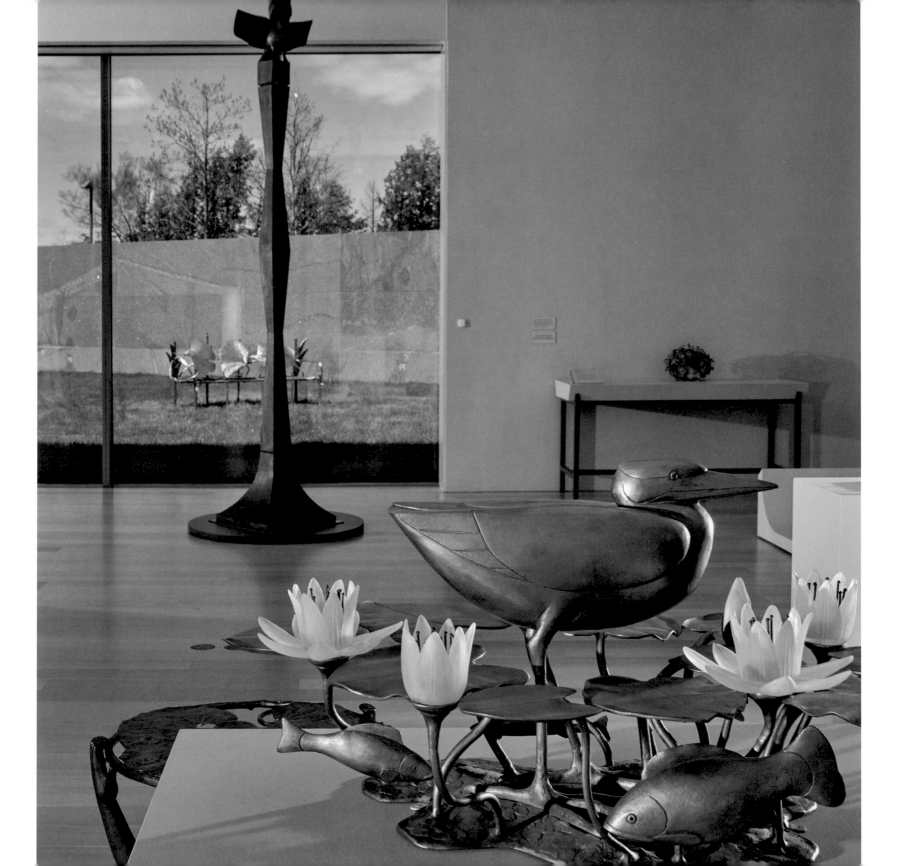

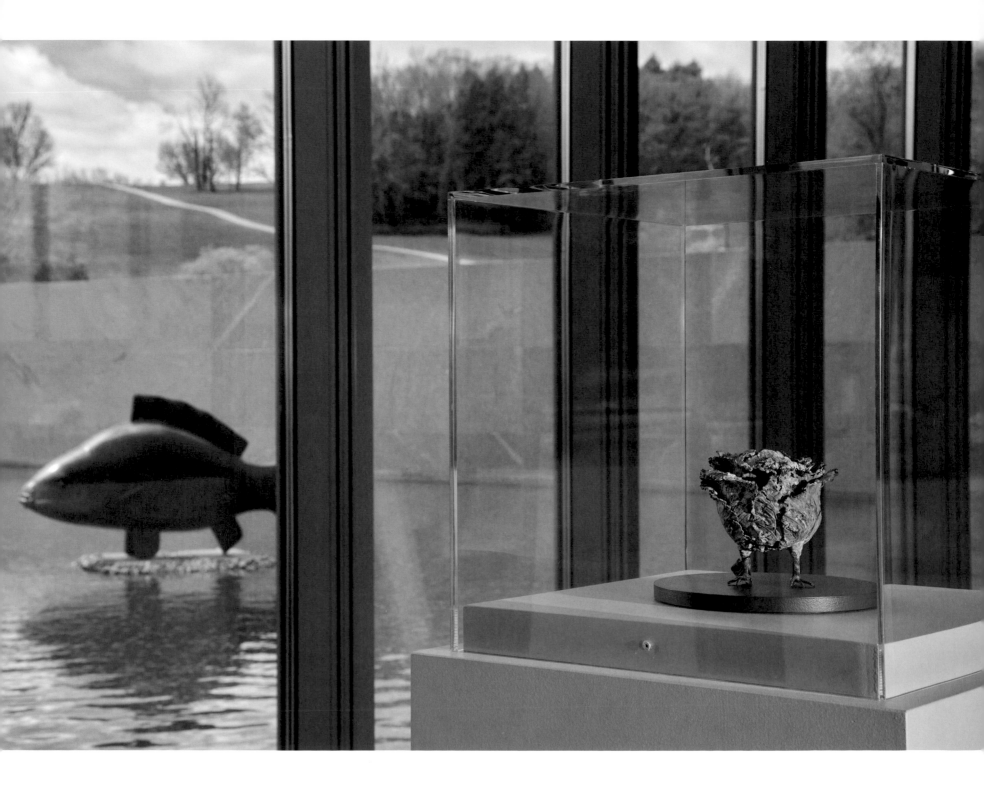

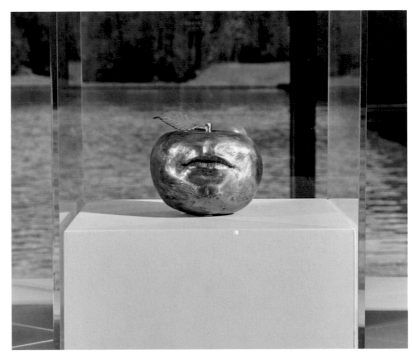

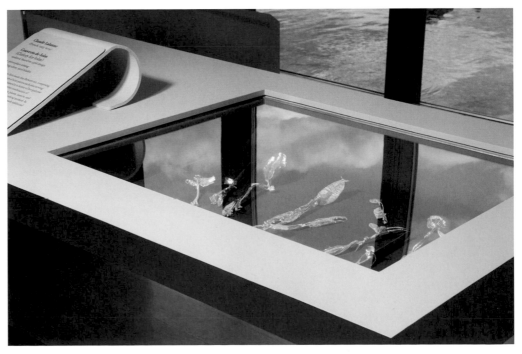

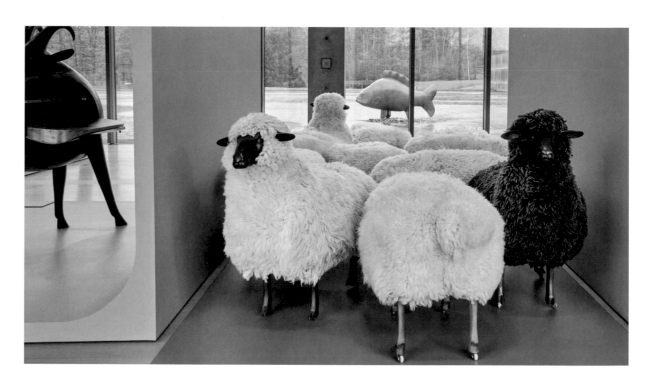

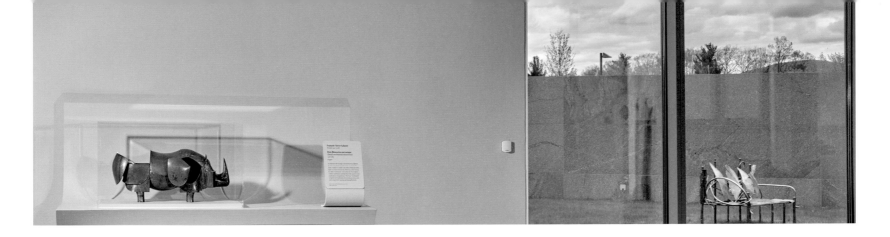

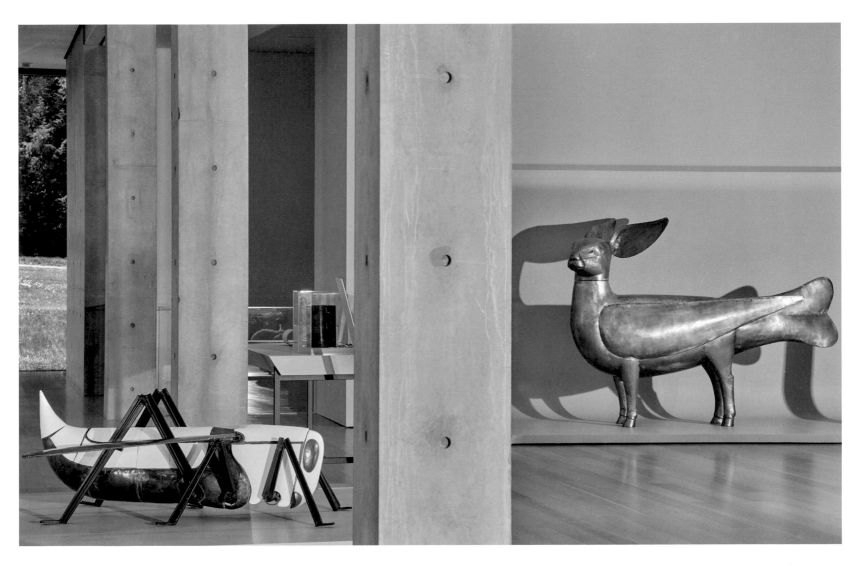

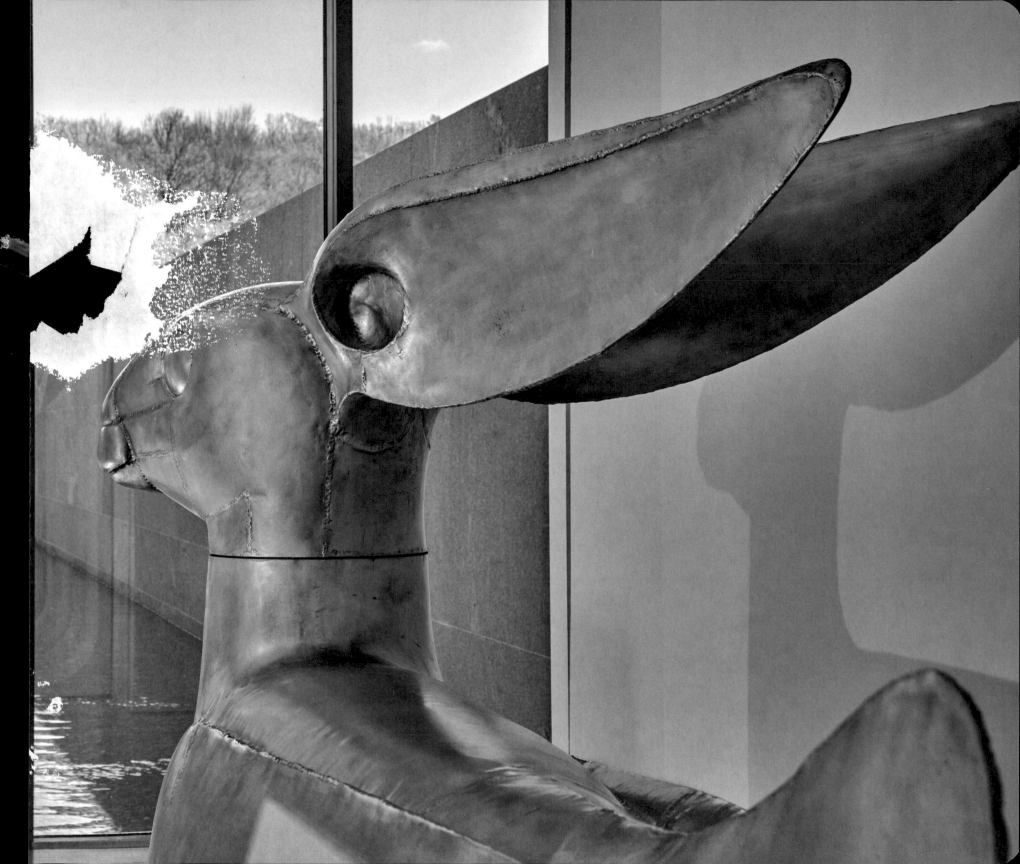

REFERENCES

SELECTED EXHIBITION HISTORY

Solo Exhibitions

1964
Zoophites: François-Xavier et Claude Lalanne, Galerie J, Paris, June 25–October 8. Exh. cat.

1966-1967
Les Lalannes, Galerie Alexandre Iolas, Paris, October 27–November 30, 1966. Exh. cat. Traveled to Art Institute of Chicago, March 7, 1966–April 2, 1967; Alexander Iolas Gallery, New York, April 18–May 1967.

1970
Les Lalannes, Galerie Alexandre Iolas, Paris, January 9-24. Works by Les Lalanne were also featured at Iolas's galleries in Milan and Geneva this year.

Dîner Cannibale, Eat Art Gallery, Düsseldorf, December.

1972
François-Xavier Lalanne, Maison de la Culture, Amiens, April 11–May 15. Exh. cat.

Les Lalannes, Dessins, Galerie Alexandre Iolas, Paris, June 14–July 1. Exh cat.

1973
Lalanne, Maison de la Culture, Amiens, October 18–December 2.

1974
François-Xavier & Claude Lalanne: An Exhibition of Extraordinary Sculpture and Jewellery, Royal Scottish Academy, Edinburgh, October 5–November 3 (postponed from January 28–March 2, 1974, due to energy crisis).

1975
Les Lalanne, Centre national d'art contemporain, Paris, June 5–July 13. Exh. cat. Traveled, as *F.X. et Claude Lalanne*, to Museum Boijmans Van Beuningen, Rotterdam, August 1–September 15.

1976
Les Lalanne, Sara Gilat Gallery, Jerusalem, May.

Domesticated Beasts and Other Creatures, Whitechapel Gallery, London, June 2–July 4. Exh. cat.

Claude Lalanne, Musée de l'Abbaye Sainte Croix, Les Sables-d'Olonne, July 15–September 31.

Les Lalanne, Musée des Beaux-Arts d'Agen, September 6–30. Exh. cat.

1977
Les Lalannes, Art Museum of South Texas, Corpus Christi, March 11–May 1.

1978
Polymorphoses, Galerie La Hune, Paris, October 10–November 30. Exh cat.

Claude Lalanne, les Sept papillons d'or, Galerie Artcurial, Paris, November–December.

1980
Les Monumentaux de Lalanne, International Art Office la municipalité de Saint-Martin d'Hères, France, October. Exh. cat.

Le Rhinocéros dans tous ses états, Galerie La Hune, Paris, November.

1982
Dépôt sentimental, Musée des Beaux-Arts d'Agen, September.

1983
Les Lalanne, Musée de Nemours, France, June 18–August 25.

1984
Les Lalanne, Christian Fayt Art Gallery, Knokke-Heist, Belgium, August 11–September 16. Exh. cat.

1985
Claude François-Xavier Lalanne, Galerie des Ponchettes, Nice, July 4–September 15. Exh. cat.

Claude et François-Xavier Lalanne, Œuvres récentes, Galerie Daniel Templon, Paris, September 21–October 26.

1986
Les Lalanne, Plaza of the Americas, Dallas, Texas, April–May. Exh. cat. Traveled to James Corcoran Gallery, Los Angeles, July 8–August 2; Greenberg Gallery, Saint Louis, Missouri, September 12–November 1.

1987
Les Lalanne, Objets extraordinaires, Galerie Artcurial, Paris, October 8–November 14.

Claude et François-Xavier Lalanne, Œuvres récentes, Galerie Daniel Templon, Paris, November 28–December 31.

1988
Les Lalannes, Marisa del Re Gallery, New York, May 19–July 2. Exh. cat.

1989
Les Dinosaures de Cl. et F.X. Lalanne, SMARTS Festival, Inauguration of the Santa Monica Promenade, California, September 16.

1991
Les Silhouettes et les Phagocytes de François Xavier et Claude Lalanne, Galerie Artcurial, Paris, April.

Les Lalanne, Château de Chenonceau, Chenonceaux, France, June 7–November 3. Exh. cat.

1992
Les Lalanne, les Portes du jardin, JGM Galerie, Paris, May 26–July 31.

1994
L'Inventaire des Lalanne: retrospective des éditions, Galerie Artcurial, Paris, May 19–July 7.

Les Lalanne, Galerie Guy Pieters, Knokke-Heist, Belgium, August 5–September 5. Exh. cat.

1996
Les Lalannes, Bao Chen Group, Taiwan, October 12–December 31.

1998
Les Lalanne à Bagatelle, Direction des Parcs et Jardins de la Ville de Paris et Association des Amis du Parc et du Château de Bagatelle, Paris, March 14–August 2. Exh. cat.

2000
Sculptures Nouvelles–Nouveaux Etats, JGM Galerie and Galerie Enrico Navarra, Paris, April 28–June 3. Companion publication: *Fragments*.

2001
The Sculpture of François-Xavier & Claude Lalanne, Gerald Peters Gallery, New York, February 8–March 10.

Les Lalanne, sculptures récentes, Galerie Guy Pieters, Knokke-Heist, Belgium, August 3–September 9. Exh. cat.

2002
Claude et François-Xavier Lalanne, Sculptures 2000–2002, JGM Galerie, Paris, May 16–June 29. Exh. cat.

2003
Bestiaire Ordinaire, JGM Galerie, Paris, December 10, 2003–January 10, 2004. Exh. cat.

2004
Bestiaire Nécessaire, JGM Galerie, Paris, December 8, 2004–January 8, 2005. Exh. cat.

2005
Claude et François-Xavier Lalanne, Sculptures 1968–2005, JGM Galerie, Paris, May 26–July 31. Exh. cat.

Bestiaire Légendaire, JGM Galerie, Paris, December 14, 2005–January 14, 2006. Exh. cat.

2006–2007
The Lalannes: Sculptures 1968–2005, Park Ryu Sook Gallery, Seoul, March 2–20. Exh. cat.

Claude & François-Xavier Lalanne, Kasmin Gallery, New York, November 16, 2006–January 13, 2007; Ben Brown Fine Arts, London, May 30–June 30, 2007. Exh. cat.

2009
Les Lalanne on Park Avenue, Kasmin Gallery, New York, September 13–November 20.

2010
Les Lalanne, Musée des Arts Décoratifs, Paris, March 18–July 4. Exh. cat.

Les Lalannes at Fairchild, Fairchild Tropical Botanic Garden, Coral Gables, Florida, November 30, 2010–May 31, 2011. Exh. cat.

2012
Les Lalanne, Kasmin Gallery, New York, May 4–June 16. Exh. cat.

2013
Claude & François-Xavier Lalanne, JGM Galerie, Paris, March 23–April 5. Exh. cat.

Sheep Station, The Getty Station, New York, presented by Michael Shvo and Kasmin Gallery, New York, September 17–December 2.

2014
Claude & François-Xavier Lalanne, Ben Brown Fine Arts, Hong Kong, February 26–March 20.

2015
Les Lalanne, 50 Years of Work 1964–2015, Kasmin Gallery, New York, March 26–May 2. Exh. cat.

Claude & François-Xavier Lalanne, Galerie Mitterrand, Paris, December 12, 2015–February 6, 2016. Exh. cat.

2016
Claude & François-Xavier Lalanne, Ben Brown Fine Arts, London, November 24, 2016–January 26, 2017.

2017
Les Lalanne, Kasmin Gallery, New York, March 16–April 22.

2018
Claude Lalanne, Galerie Mitterrand, Paris, April 14–May 27.

François-Xavier Lalanne, Galerie Mitterrand, Paris, June 2–July 28.

Les Lalanne, Ben Brown Fine Arts, London, November 29, 2018–February 15, 2019.

2019
Les Lalanne, Kasmin Gallery, New York, January 24–March 9.

Les Lalanne at The Raleigh Gardens, Raleigh Hotel, Miami Beach, presented by Michael Shvo, November 24, 2019–February 29, 2020.

Group Exhibitions

1964
Salon de la Jeune Peinture, Musée d'Art Moderne de la Ville de Paris, January 12–February 3.

Le Main, Galerie Claude Bernard, Paris, December.

1965
Salon de la Jeune Peinture, Musée d'Art Moderne de la Ville de Paris, January 10–February 1.

1966
Salon de la Jeune Peinture, Musée d'Art Moderne de la Ville de Paris, January 9–February 1.

1971
Bienal de São Paulo, Brazil, September 4–November 15.

1972
Furniture by Artists, Leo Castelli Gallery, New York, September 7–23.

1977
Dessins étranges, Objets et Sculptures Insolites, organized by Musée National d'Art Moderne, Centre Pompidou, Paris, January 1977–May 1979. Venues included Musée des Beaux-Arts, Lyon; Centre d'animation des Fontaines, Tours; Musée Antoine-Lécuyer, Saint-Quentin; and Maison des Jeunes et de la Culture, Annemasse.

Improbable Furniture, Institute of Contemporary Art, University of Pennsylvania, Philadelphia, March 10–April 10. Exh. cat. Traveled to La Jolla Museum of Contemporary Art, California, May 20–July 6.

Artiste/Artisan?, Musée des Arts Décoratifs, Paris, May 23–September 5. Exh. cat.

1980
Les Métiers de l'art, Musée des Arts Décoratifs, Paris, November 27, 1980–March 30, 1981.

1981
Art contemporain en France 1960–1980: Un certain choix, Musée National Jordanien des Beaux-Arts de Amman, Jordan, March 1–25. Exh. cat.

1985
Monstres sacrés, Salles romanes de Cloître St. Trophime, Arles, June–September. Exh. cat.

1989
Art de vivre: Decorative Arts and Design in France 1789–1989, Cooper-Hewitt Museum of Decorative Arts and Design, New York, March 30–July 16. Exh. cat.

SELECTED BIBLIOGRAPHY

Abadie, Daniel. *Lalanne(s): The Monograph*. Paris: Flammarion, 2008.

A. James Speyer papers, Institutional Archives, The Art Institute of Chicago.

Ashbery, John. *Les Lalanne*. Exh. cat. Dallas, Texas: Plaza of the Americas, 1986.

———. "Segui Shows Horrors in Double Paris Show." *New York Herald Tribune*, October 6, 1964, 5 (Paris edition).

Banier, François-Marie. "Une Forte Tête." *Elle* (January 1974), 108–9 (Paris edition).

Barotte, René. "Les Lalanne qui sculptent pour la vie quotidienne." *Sud-Ouest*, November 29, 1966, 13.

Barry, Edward. "We Give Up! What Is Art?" *Chicago Tribune*, March 5, 1967, E2.

Bergé, Pierre. "Claude et François-Xavier logent la poésie chez Alexandre Iolas." *Combat*, October 27, 1966, 9.

Bergé, Pierre, Peter Marino, Reed Krakoff, and Adrian Dannatt. *Claude and François-Xavier Lalanne*. New York: Reed Krakoff, Paul Kasmin, and Ben Brown, 2006.

Bouyeure, Claude, and Marie-Claude Volfin. "Les Lallanne [sic] (Galerie Alexandre Iolas)." *Les Lettres françaises*, July 19, 1972, 26.

de Broglie, Jeanne-Marie. "Lalanne Land." *Connaissance des Arts*, no. 454 (December 1989): 118–21.

Callaway, Nicholas. "Origin of Their Species." *Departures* (September 2007): 109–10. https://www.departures.com/shopping/worldly-goods/origin-their-species.

Campbell, Lawrence. "Claude and François-Xavier Lalanne at Marisa del Re." *Art in America* 77, no. 2 (February 1989): 166–67.

Cau, Jean. "Lalanne: Une imagination en délire, un bon sens colossal." *Vogue* (April 1966): 148–53 (Paris edition). Reprinted as "Marvellous Trickery: The Joy of the Invented Objects of François and Claude Lalanne." *Vogue* (April 15,1967): 140–51 (New York edition).

Chislett, Helen. "Claude Lalanne: Behind the Scenes with the Fabled Sculptor, Who Has Died Aged 93." *Financial Times*, April 11, 2019. https://howtospendit.ft.com/art-philanthropy/112213-two-chances-to-step-into-claude-lalannes-wonderland.

Claude & François-Xavier Lalanne. Paris: Galerie Mitterrand, 2016.

Dannatt, Adrian, ed. *Alexander the Great, the Iolas Gallery, 1955–1987*. New York: Paul Kasmin Gallery, 2014.

———. *François-Xavier and Claude Lalanne: In the Domain of Dreams*. New York: Rizzoli International Publications, 2018.

———. ed. *Les Lalanne: Fifty Years of Work, 1964-2015*. New York: Paul Kasmin Gallery, 2015.

Delassein, Sophie. "Les inclassables Claude et François-Xavier Lalanne." *L'Oeil*, no. 476 (November 1995): 58–61.

Desanti, Dominique. "L'objet dans notre vie." *Le Nouveau Planète*, no. 15 (March–April 1970): 102-7.

Drohojowska, Hunter. "This Pricey Menagerie Is More Fun Than Fine Art." *Los Angeles Herald Examiner*, July 13, 1986, E1.

d'Elme, Patrick. "The Story of the Lalannes." *Cimaise* (January 1970): 54–68.

———. "Les Lalanne." *Mobile, Maison de la culture d'Amiens*, no. 17 (November 1973): unpaginated.

Emerson, Gloria. "'They Are Not Furniture,' He Said, Sitting on a Sheep." *New York Times*, October 12, 1966, 46.

Ernould-Gandouet, Marielle. "Les Lalanne dans la nature." *L'Oeil*, no. 434 (September 1991): 60–65.

Ferrier, André. "Le mois du Blanc." *Le Nouvel Observateur*, January 21, 1965, 32–33.

"Figurative Furniture: The Work of Claude and François Lalanne." *Harpers & Queen* (March 1971): 64–67.

Forest, Dominique, and Béatrice Salmon, eds. *Les Lalanne*. Exh. cat. Paris: Musée des Arts Décoratifs, 2010.

"Furniture on the Hoof." *Chicago Sun Times*, March 19, 1967, 18–22.

Gaillemin, Jean-Louis. "Atelier Lalanne." *Architectural Digest* (February 1981): 112–19.

Grey, Tobias. "Next to Nature, Art." *Wall Street Journal*, June 20, 2013. https://www.wsj.com/articles/SB10001424127887324520904578551062812849802.

Hahn, Otto. "Les moutons de Lalanne." *L'Express*, January 24–30, 1966, 45–46.

———. "L'inventaire des Lalanne." *L'Express*, June 16–22, 1975, 28.

Jansen, Eric. "L'oeuvre poétique de Claude et François-Xavier Lalanne." *Point de Vue*, no. 2588, February 25–March 3, 1998, 40-43.

John Ashbery Papers, *97M-43, Box 26 (HH1KQN), Folder: Les Lalanne. Houghton Library, Harvard University, Cambridge, Massachusetts.

"Just Call Them 'Lalannes,'" *Interiors* 126 (May 1967): 16.

Kenedy, R. C. "Paris Letter." *Art International*, no. 9, November 20, 1966, 60–66.

Lalanne, Claude. "Interview with Claude Lalanne." By Alain Elkann. Alain Elkann Interviews (February 2017), https://www.alainelkanninterviews.com/claude-lalanne/.

Lalanne, Dorothée. "Les Lalanne: Les Silhouettes et les Phagocytes." Special issue, *AURA: Cahiers d'Artcurial*, no. 1 (April 1991). Published in English in *Claude & François-Xavier Lalanne*. Paris: Société Internationale d'Art Moderne; JGM Galerie, 2013.

Lalanne, François-Xavier. *Polymorphoses*. Paris: La Hune, 1978.

Lascault, Gilbert. "Le luxe et la vie." *Paris-Normandie (Vexin-Mantois)*. January 23, 1970, 9.

Lassaigne, Jacques. "França." *Catálogo da 11ª Bienal de São Paulo*. São Paulo: Fundação Bienal de São Paulo, 1971, 88–89. https://issuu.com/bienal/docs/name9839c4/82.

Marchesseau, Daniel. "Accrochages en tous genres." *Les Nouvelles littéraires* (May 6–12, 1974): 16.

———. *The Lalannes*. Paris: Flammarion, 1998.

Marino, Peter. *The Garden of Peter Marino*. New York: Rizzoli, 2017.

Mason, Rainer Michael. "Les expositions à Genève." *La Tribune de Genève*, October 15, 1971, 39.

Mauries, Patrick, and Jean-Gabriel Mitterrand. *Claude et François-Xavier Lalanne: Sculptures 2000–2002*. Paris: STIPA; JGM Galerie, 2002.

Metcalf, James. *François Xavier et Claude Lalanne: Objets*. Exh. cat. Paris: Galerie J, 1964.

Nourissier, François. *Les Lalannes*. Trans. Conrad Wise. Paris: Galerie Alexandre Iolas, 1966.

de Nussac, Patrice. "Un taxi pour Lomé." *Paris-Presse*, October 22, 1966.

Peignot, Jérôme. "Lalanne." *Connaissance des Arts*, no. 176 (October 1966): 120–23.

———. "Des cadeaux de non anniversaire." *Le nouvel observateur*, no. 102 (October 26–November 1, 1966): 51–52.

Piguet, Philippe. "Les Lalanne: la sculpture domestiquée." *L'Oeil*, no. 624 (May 2010): 47–52.

Pluchart, François. "De Raysse à Lalanne, Alexandre Iolas répond aux interrogations de la sensibilité actuelle." *Combat*, October 31, 1966, 7.

Ragon, Michel. "L'art modern exerce-t-il une influence sur le décor de notre vie?" *Jardin des Arts* (April 1965): 14–23.

Restany, Pierre. "Les Lalanne ou le reve à la maison." *Domus*, no. 518 (January 1973): 38–41.

Roditi, Édouard. "Letter from Paris: Surrealism Resurrected." *Apollo* 83 (May 1966): 380–82.

———. "Paris: The Occident Revisited." *Arts Magazine* 39, no. 6 (March 1965): 70–73.

———. "Paris: The Winter's High Jinks." *Arts Magazine* 40, no. 6 (April 1966): 50–51.

Rosenblum, Robert. *Les Lalanne*. Geneva: Skira, 1991.

Ruas, Charles. "Claude and François-Xavier Lalanne: Paul Kasmin." *ARTnews* 106, no. 2 (2007): 134–35.

Russell, John, and Gilbert Brownstone. *Les Lalanne*. Paris: SMI; Centre National d'Art et de Culture Georges Pompidou, 1975.

Saint Laurent, Yves. "Mon ami Claude." *Vogue* (June/July 1994): 162 (Paris edition).

Sheppard, Eugenia. "Not Quite Furniture." *World Journal Tribune*, April 12, 1967, 17–19 (New York edition).

Speyer, A. James, and Allen Wardwell. "Sculpture by Claude and François-Xavier Lalannes." Gallery brochure. Chicago: Art Institute of Chicago, 1967.

Willsher, Kim. "Fantastique Beasts: Cult Art from the Lalannes' Private Collection to Go On Sale." *Guardian*, July 20, 2019. https://www.theguardian.com/artanddesign/2019/jul/20/fantastique-beasts-french-lalanne-collection-on-sale-cult-art.

Wise, Bill. "Nothing like Creatures for Creature Comfort." *Life*, February 3, 1967, 76–79.

ILLUSTRATION CREDITS

Published by the Clark Art Institute on the occasion of
the exhibition *Claude & François-Xavier Lalanne: Nature Transformed*,
Clark Art Institute, Williamstown, Massachusetts, May 8–
October 31, 2021

Claude & François-Xavier Lalanne: Nature Transformed is organized
by the Clark Art Institute, Williamstown, Massachusetts.

Major support for *Claude & François-Xavier Lalanne: Nature
Transformed* is provided by Denise Littlefield Sobel. Significant
funding is provided by Sylvia and Leonard Marx and by the Kenneth C.
Griffin Charitable Fund, with additional support from Jeannene
Booher, Agnes Gund, and Robert D.
Kraus. The exhibition catalogue has been
published with the generous support of
Denise Littlefield Sobel, with additional
support from the Kenneth C. Griffin
Charitable Fund and Furthermore: a
program of the J.M. Kaplan Fund.

Furthermore:
a program of the J.M. Kaplan Fund

Produced by the Publications Department of the
Clark Art Institute
225 South Street
Williamstown, Massachusetts 01267
Clarkart.edu

Anne Roecklein, Managing Editor
Kevin Bicknell, Editor
Samantha Page, Assistant Editor
David Murphy, Rights and Image Use Associate
Elisama Llera, Publications Intern
Gabriel Almeida Baroja, Publications Intern

Copyedited and proofread by Pickman Editorial
Designed and typeset by Jen Rork Design
Printed and bound in the United States by Puritan Capital

Distributed by Yale University Press
302 Temple Street
New Haven, Connecticut 06520
Yalebooks.com/art

10 9 8 7 6 5 4 3 2 1
Library of Congress Cataloguing-in-Publication Data

Names: Morris, Kathleen M., 1959- author. | Sterling and Francine
 Clark Art Institute, organizer, host institution.
Title: Claude & François-Xavier Lalanne : Nature Transformed /
 Kathleen M. Morris.
Other titles: Claude and François-Xavier Lalanne
Description: Williamstown, Massachusetts : Clark Art Institute, 2021. |
 Includes bibliographical references. Summary: "Claude
 (1925-2019) and François-Xavier (1927-2008) Lalanne were a
 husband-wife team of artists who created inventive and often
 surprising works that have been widely admired and collected
 since the 1960s. This book presents a carefully selected group of
 sculptures that focus on a shared preoccupation of the artists: the
 transformation of natural forms to serve new purposes, such as
 François-Xavier's giant grasshopper sculpture that opens into a
 bar and Claude's bench made of galvanized metal branches and
 vines such that it remains as much a forest as a place to sit. Critical
 analysis explores the full breadth of the artists' careers; considers
 the complex issues of reception and categorization of their work;
 and prompts a reevaluation of the place their art occupies in the
 context of art museums, all while encouraging readers to consider
 relationships among nature, art, and their own encounters with
 both"-- Provided by publisher.
Identifiers: LCCN 2020015631 | | ISBN 9781935998433 (paperback :
 Sterling and Francine Clark Art Institute) | ISBN 9780300250848
 (paperback : Yale University Press)
Subjects: LCSH: Lalanne, François Xavier--Exhibitions. | Lalanne,
 Claude--Exhibitions. | Nature (Aesthetics)--Exhibitions. |
 Animals in art--Catalogs.
Classification: LCC NB553.L247 A4 2021 | DDC 730.92/2--dc23
LC record available at https://lccn.loc.gov/2020015631